VIBRANT FLOWER PAINTING

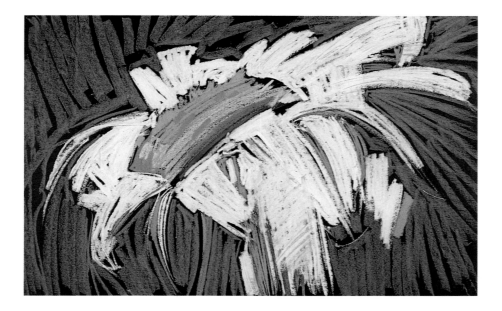

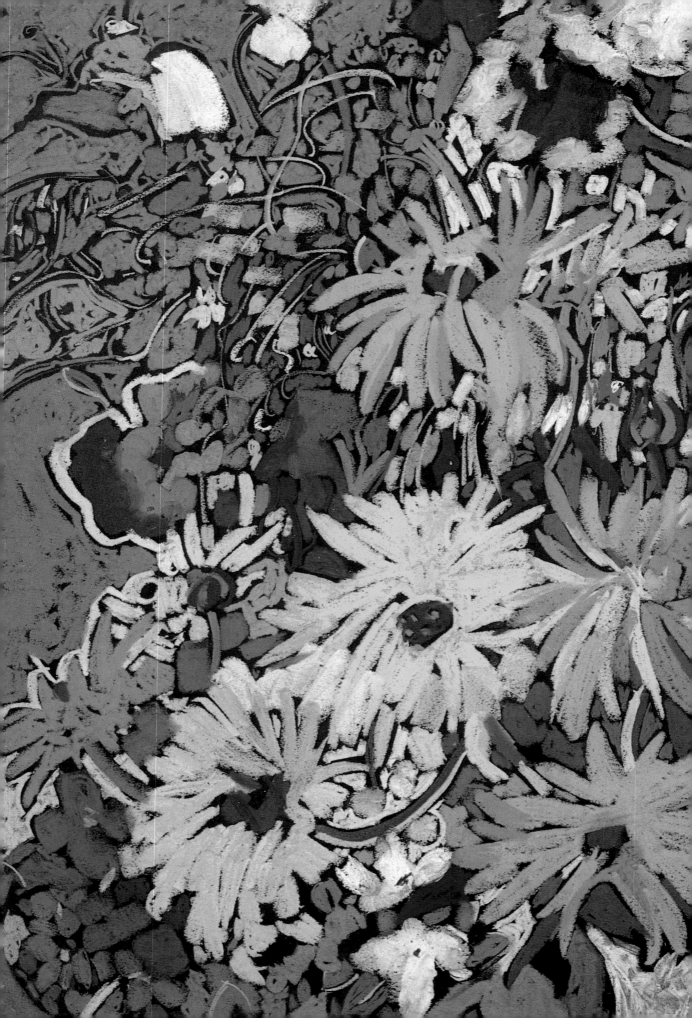

VIBRANT FLOWER PAINTING

Frances Treanor

David & Charles

FOR BIDDY MAUNSELL

A DAVID & CHARLES BOOK
Copyright © Frances Treanor 1995
First published 1995

A catalogue record for this book is available from the British Library.

ISBN 0 7153 0247 7

Designed and typeset by Cooper Wilson Design
and printed in Singapore by CS Graphics
for David & Charles, Brunel House, Newton Abbot, Devon.

Preliminary illustrations:
PAGE 1 'Daisy Head'
25½x38in (65x96.5cm). Oil pastel/chalk.
*I really let go in this painting after spending the whole day working in a more
analytical manner.*

PAGES 2–3 'Pansies and Chrysanthemums'
25x35 in (63.5x89cm). Soft pastel.

CONTENTS

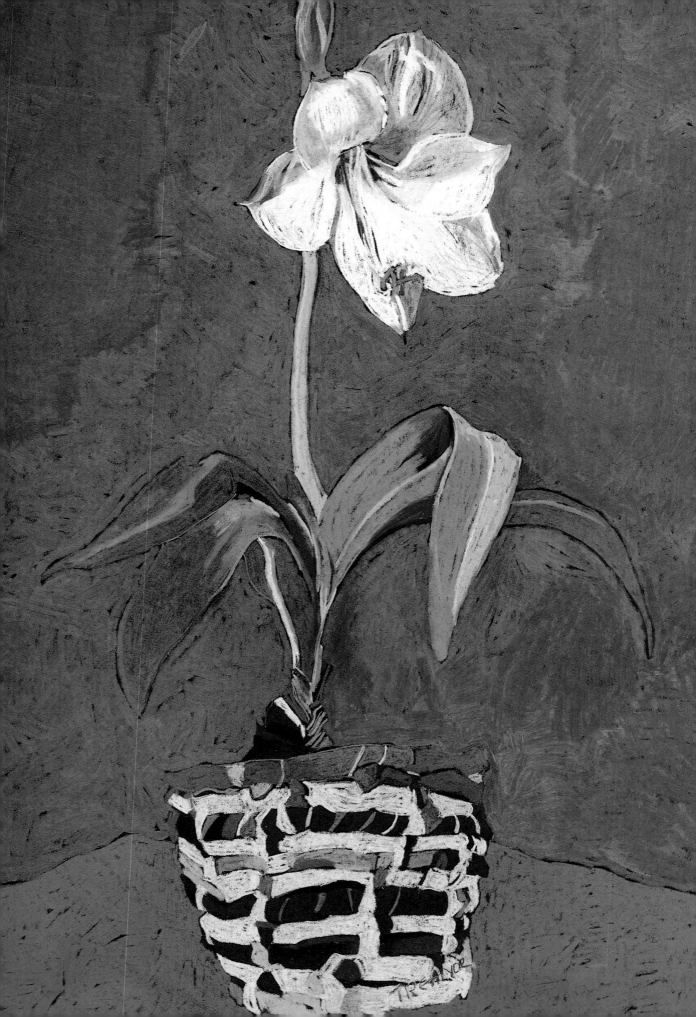

Chapter 1
WHAT IS PASTEL?

. .

A BRIEF HISTORY

The amazingly well-preserved prehistoric images, drawn on the Lascaux caves in the Dordogne region of France, are some of the earliest known paintings. The colours were made by mixing earth with the rich, thick blood, fat and resin of animals and these 'magical' images were outlined with sticks of wood scorched by fire. The modern name given to this primitive drawing stick is charcoal and it is still a popular drawing medium today.

Up until the fifteenth century in western Europe, there was no real distinction between craftsman and artist, and the more personal, visual observations and interpretations of the world through an artist's eye have not been well documented. Only established, religious imagery has survived, gaining recognition by appearing in books and manuscripts, many of which are beautifully painted and highly decorative.

During the quattrocento period in Italy, drawing became an obligatory skill and the use of white chalks and charcoal was much encouraged and exploited by great artists such as Botticelli, Leonardo and Michaelangelo. The latter was renowned for his sanguine on cream paper drawings, but these 'cartoons' were often viewed simply as a prerequisite for the more 'noble' art of oil and tempera painting.

LEFT **'Amaryllis'** 38x25in (96.5x63.5cm). Oil pastel.

BELOW **'Tudor Flowers'** 25x36in (63.5x91.5cm).
Soft pastel.
A semi-abstract composition based on flowers.

This technique was made especially popular by the Italian portrait artist, Carriera, and her male counterpart, the French pastellist Perroneau. The pastel portraits of Quentin de la Tour, in the museum of St Quentin in northern France are pleasantly surprising in their freshness and the unexpected use of a blue silhouette surround.

The most important breakthrough for the pastel medium came in the late nineteenth century, when artists such as Degas, Renoir, Manet and later Toulouse-Lautrec put the emphasis on to pure colour, and away from the subdued earth tones of Conté and sanguine, which had been so favoured by the artists of the Renaissance.

Today there are many artists who use pastel in different ways, utilizing a diversity of techniques, and many, too, who are not afraid to break with a sentimental drawing tradition that has been partially responsible for the low image of pastel drawing.

MODERN PASTEL

Pastel is pure pigment in a powdered consistency, moulded into a dry, coloured, chalk stick. A binder, usually of gum tragacanth, is added to prevent it crumbling on contact with a surface such as paper. If water is applied to this pigment, it turns into watercolour. If linseed oil is added, it becomes oil paint.

As a dry paint, the tactile nature of pastel is both immediate and sensually intimate, rendering brushes, mixing palettes and prepared surfaces obsolete. Vibrant, imaginative images can be achieved with maximum speed and the minimum of fuss. It is therefore a superb medium for artists of all ages and ability, provided they don't mind getting their hands dirty!

The colour and texture range in pastel are as varied as flowers in a garden. It can take a little time to familiarize oneself with the extensive range, but basically pastel falls into three categories: hard pastel, soft pastel and pastel pencil.

HARD PASTEL

There is something magical about a wooden presentation box filled with pastels of all the colours of the rainbow. The temptation to pick up a pas-

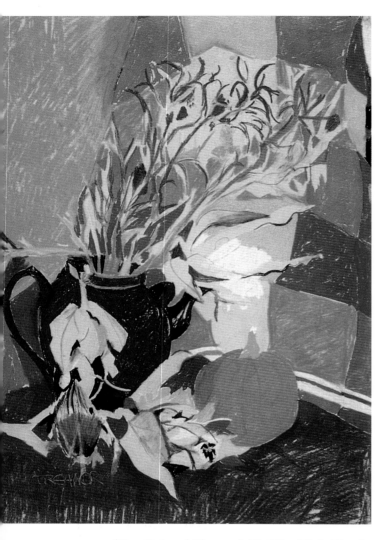

ABOVE **'Tea Pot and Flowers'** 29x22in (73.5x56cm). Soft pastel on grey sugar paper.

The sixteenth century brought an awareness of colour tone, through artists such as Titian, who portrayed line through the use of charcoal and black chalk — a rather softer charcoal pencil still in use today — the pigment of which was extracted from coal or Italian stone. Drawings had now given way to tonal masses, and form was defined through contrast in tonal values of light and dark.

It was not, however, until the eighteenth century that drawing on paper experienced a spectacular rise in popularity. The technique most commonly used during the rococo period in France was *dessin a trois crayons* — a mixture of charcoal, red and white chalk on coloured paper.

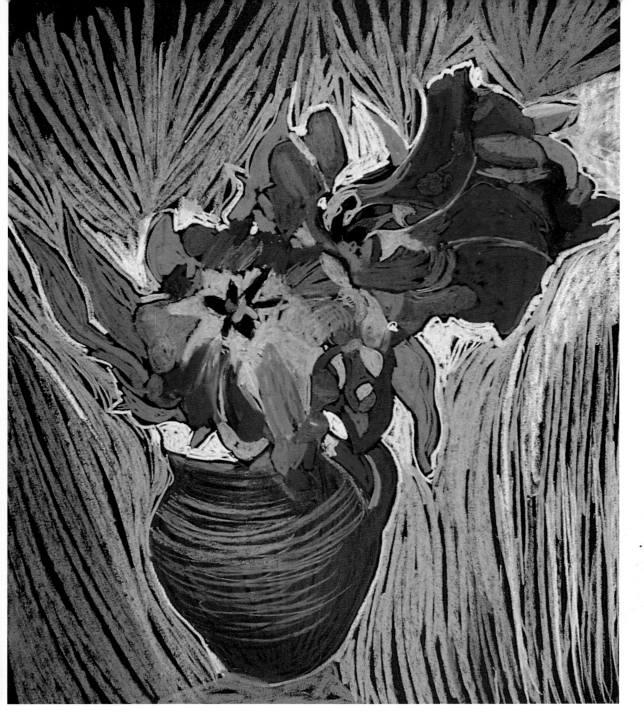

ABOVE **'Two Tulips'** 30x25in (76x63.5cm).
Soft pastel and chalk.
A composition devoid of any background which would position it in space.

tel and use it is overwhelming. High-quality soft pastels are expensive, however, and can vanish in seconds if applied too roughly on the wrong surface. I would therefore encourage those of you who may not have used the medium before to start with a small selection of Conté crayons – they are harder, much more controllable and cheaper to buy. After a little while, it will then be possible to explore the wonderful range of softer pastel. Hard pastel is easily identifiable by its firm, small, sharp rectangular edges. Its brittleness and strength is achieved by the addition of extra proportions of gum binder or hardening

agents. This firmness is ideal for controlled line drawing; in fact, Carres Conté crayon in colours such as sepia, sanguine, bistre or black are the traditional chalks which have been used over the centuries in art studios throughout the world.

Large surfaces can be covered if the crayon is used on its side, which also gives a wider line and an evenness of tone. Sharpening the tip gives

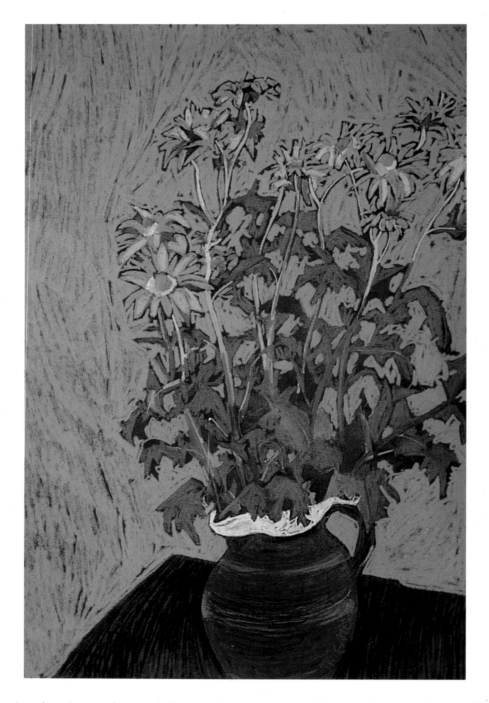

a more precise drawing and areas of particular interest such as focal points can be highlighted. I prefer not to sharpen my chalks except in the case of oil pastel, when I sometimes find it necessary to remove the residual film of grease or dirt that builds up on the surface. However, I take care not to damage the inner layer by gently scraping away debris with a slightly blunted blade used on its side. Using this method, one avoids making an imprint that could be unwittingly transferred to the paper.

Grey and white crayons are normally used for tone and shadow effects. White crayon can be very striking on a dark-toned paper and sepia works well on sugar paper. Other colours are available in hard chalks, but the range is very limited because of the black pigment used in its manufacture. I am particularly fond of red lead

LEFT **'Chrysanthemum'** 38x25in (96.5x63.5cm). Soft pastel.

RIGHT The white flower silhouettes are formed by using the blunt edge of blue oil pastel on an A4 ivory board pad. The underlying white paper is allowed to show through in a positive and negative manner. Linear curves are then applied with the tip of the pastel.

and light green No 8. By snapping a green Carres Conté in half, I have been able to make excellent curved leaf veins with amazing accuracy in one fell swoop.

SOFT PASTEL

As the name implies, these pastels are softer than hard crayon. They are usually round in shape and white gypsum added to the pastel is responsible for its delicacy and luminosity. Soft pastels are more expensive than hard crayons because they are usually made from the finest pigments, ground with a mixture of chalk, clay and other ingredients. Colour strength is dependent upon the actual amounts of clay used. As less binder is added to soft pastel, it tends to crumble more, but any loose bits can be easily blended out.

Very soft pastels such as Sennelier or Daler-Rowney are difficult to handle without their tissue wrappers around them. Quentin de la Tour encase each pastel in a see-through hard plastic tube which protects the pastel and doubles up as a holder. For years I kept a box of pastels hidden away because I thought them too precious to use all in one go. Instead I picked out one at a time when I wanted a particularly luminous colour and replaced it, when finished, with a new one.

It is very tempting to blend all your work when working with soft pastels, but this will affect their brilliance. I recommend placing and pressing instead, a technique that works well for face powder when applying make-up. Minute particles will inevitably fall off but you will have to accept this, otherwise you will spend most of your time with an eraser. Do not wipe the dust away, but blow very gently instead or, if practical, lightly tap the back of your paper support every so often, allowing the residue to accumulate on a single sheet of newsprint. This can either be thrown away or recycled – recycling is

technically possible with the addition of gum tragacanth or water. Some pastels are so soft that fixative can blow pigment away. It this happens, it is better to use a sanded paper.

The natural vibrations caused by the body's movements as you work can also disturb powder pigment, increasing the chances of accidental colour blending, especially if the paper is supported on an upright easel. Tilting the easel or board into a more horizontal position usually solves such problems, but do not have a support in too flat a position or you risk smudging work with your arm or sleeve. Fixing in short bursts as you progress, with a final longer fix when you have finished, will also make soft pastel adhere to its surface.

Soft pastel does not travel well. I prefer to work with it only in my studio, using Rembrandt for everyday use and keeping my large Unisons and Senneliers for those special occasions when I want to enrich a colour or revive a hue dulled by over-fixing.

OIL PASTEL

Oil pastel has two main advantages over powder pastel: it will not break so easily and the need for a fixative is eliminated because the pastel clings

like glue to paper or board. The colour range is rather limited compared to powder pastel and the tones are darker. Sometimes the colour can sink into soft paper or disappear altogether on an unprimed surface. If you haven't the time to prepare your surface in advance, it is worth experimenting with watercolour papers. However, white cartridge or brown wrapping paper give lovely results.

I use Acco-Rexel ivory board. The firm, strong, shiny surface allows oil pastel to glide over, and the translucent nature of the medium lets underlying layers of colour show through. But be careful not to overlap colours too much or they will become bland and unattractive. If this happens, it is possible to scrape off the top layer in order to reveal the original surface – a

process called *sgraffito*. White oil pastel applied in a complete overlay on top of all colour on a finished painting is very effective.

Oil and wax added to pastel make it into a real painting medium, and giant sticks of oil bars are now available. It is fun to experiment with turpentine or white spirit applied with a hog brush. Colour will, however, lose its brilliance in this adulterated state and both pigment and paper will harden as they dry.

Fixative is not necessary for oil pastel, but Caran d'Ache of Switzerland recommend their own protector for their neo-pastel. I find Caran d'Ache neo-pastel very malleable and subsequently very pleasurable to use: slightly softer

BELOW Pastel pencil 6½x6½in (16.5x16.5cm).

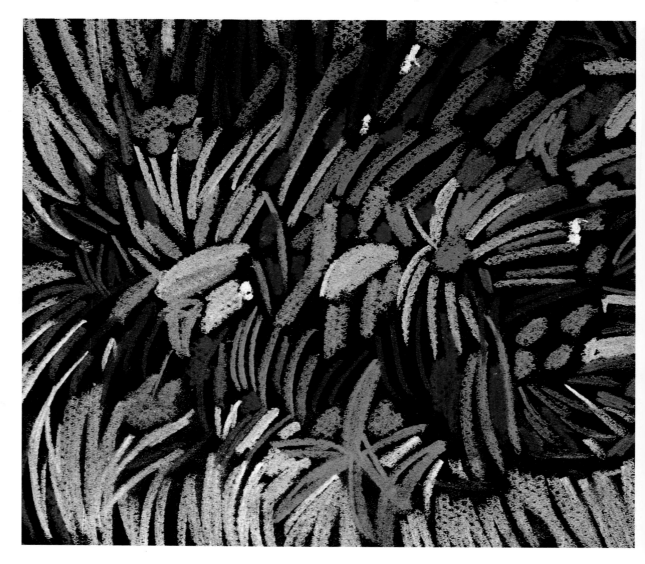

ABOVE Blended and smudged pastel pencil 8x6in (20.5x15cm).

than ordinary oil pastel, it does not become as brittle in cold temperatures and it adheres to surfaces without a trace of dust or grease residue, unlike other oil pastels. Its softness makes finger application a bit messy so I find it better to wait until the pastel has dried out a little before applying another overlapping colour.

Over the years, I have lost my range of Talens-Panda oil pastels as they have become unrecognizable through layers of grime. Interesting, unusual colour juxtapositions have been created when I have accidentally picked up a pastel believing it to be a dark colour, only to discover that it was a lighter yellow or white. As I work at great speed, I tend to accept these accidents. If you cannot, then you will have to discipline yourself by keeping your pastels separate from each other, perhaps in wood or plastic trays, or even corrugated cardboard filled with rice. Alternatively, you can annually spring-clean the whole lot with a dab of white spirit soaked in a cotton cloth, or with a razor blade.

WAX CRAYON

Colour mixed with heated wax is one of the oldest ways of creating a drawing, and the technique known as encaustic was popular in the ancient world of Egypt, Greece and the Roman Empire.

In the modern world, crayons are really only used with enthusiasm by the youngest members of society. Older children seem to abandon them as soon as they are out of nursery for what they imagine are more sophisticated art materials: felt-tips and biro pens. This is a pity, because while children can gain quite remarkable skills in line drawing with these tools, it is to the detriment of overall colour and shape. However, it is very exciting to witness a renewed interest in chalks and pastels today. I suspect the latest inventions of oil bars and water-soluble pastel pencils have something to do with this.

Wax crayon basically has the same properties as oil pastel, except that the wax is softer, greasier and cheaper to buy. Children adore spreading crayons around with fingertips; it is a good way to introduce them to pastel. Less translucent than oil pastel, it can eliminate the grain in paper if overlayers are applied too heavily. Should this occur it is easily erased with a palette knife, provided the wax has not dried out. Interesting textures can also appear from underlying surfaces when the previous layers are scratched away, for unlike oil pastel, which is softer and less opaque, light wax crayon colour will not show through darker pigment.

Although I enjoy playing around with multiple layers of wax crayon on white paper, it is worth remembering that the medium is not permanently colour-fast and the colour can fade quite rapidly if put under a glass frame exposed to direct sunlight. I reserve my more serious work for oil pastel, using top quality acid-free supports.

PASTEL PENCILS

My flower paintings are large compared to most botanical artists' and the bigger the pastel or crayon, the more I like it. However, I adore intricate detail and accuracy and creating intriguing focal points. Iris heads or the black stamens

of tulips are ideal subjects for detailed, precise drawing and observation. Although the intensity of colour is weakened in pastel pencil because of the binding mediums, it is possible to develop a gentler palette by working in a tertiary field of colour. In my painting 'Autumn' (page 54), I deliberately limited my composition to exploring in depth the range of tertiary and secondary colours produced by the Derwent pencil manu-

cils suit my temperament in the Côte d'Azur, my favourite pencils come from the Derwent range, especially ivory black and ultramarine. They produce a set of tertiary colours which glide smoothly over their ivory board sketch pads, helping me to make very quick outline drawings.

BELOW **'Winter Chrysanthemums'**
25x38in (63.5x96.5cm). Soft pastel.

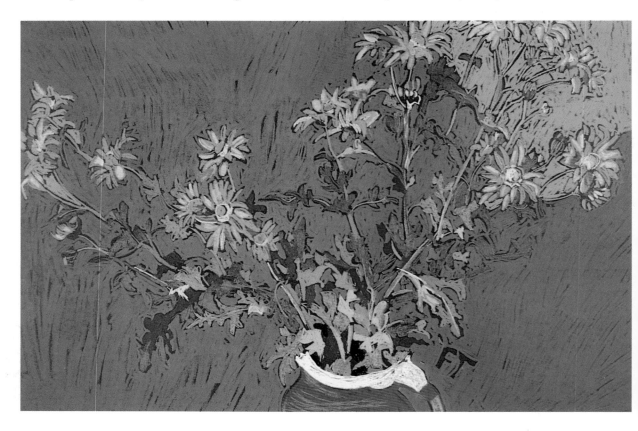

factured by Acco-Rexel, a family company established over a hundred and fifty years ago with a reputation for reliability and excellence. The pigments used are now no longer indigenous to the region, but the earth tones so popular with the early nineteenth-century watercolourists are still true to the mountainous region of England where they originated and the earth colours of Rexel pastels echo the misty, dark indigo skies.

Conté pastel pencils and Carb-Othello, on the other hand, are more primary colour orientated and suitable for a bright, sunny continental temperament.

Although the vibrant primaries of Conté pen-

I rarely like to carry soft pastels when travelling on public transport because they are easily broken, yet become heavy and bulky if packed in a box. Pastel pencils are therefore necessary for any artist who wishes to work out of doors on a small scale. Fixing is not really necessary until you return home, and I find that placing a soft sheet of kitchen paper between each drawing is enough to protect the work.

It is important to protect the tips of pastel pencils when travelling, so remember to take bubble-wrap and elastic bands, plus a retractable blade for sharpening.

Good quality pastel pencils such as the Acco-Rexel Derwent range are available in cedar

ABOVE Charcoal with neo-pastel 6½x7½in (16.5x19cm).

wood presentation boxes complete with handle. Cheaper ranges from other manufacturers are often contained in metal cases, which I find inconvenient after a while, particularly if the lids refuse to close properly. Pastel pencils are such a luxury that I think it is worthwhile paying a bit extra in order to store and preserve them. In my studio, I find it very easy to place my small pastel presentation box on a table next to my easel, but I'm reluctant to take it outside in case it rains. Instead, I have invented a temporary method of storing them which suits my needs very well: taking all the pastel pencils out of their containers, I turn them upside down. This enables me to see the colour codes more easily: some manufacturers cover the whole stick with one colour for identification, but others show only the pigment tip. With the bottom of my pastel pencils uppermost, I put them into a large coffee jar, which has a synthetic cosmetic sponge at its base to prevent damage to the pencil tip, and store them with the lid on.

Miscellaneous pastel pencils also look very eye-catching in old ceramic pots scattered around the studio.

CHARCOAL

Most students at art school are introduced to charcoal at an early stage in their careers. In my own studio, I have masses of vine and willow sticks gathering dust from those days. It was only recently that I started to use the medium again after a company asked me to test a new range of charcoal encased in pencil-shaped wooden barrels. The drawings I made using the products were surprisingly good. This was because I had greater control and the fragile charcoal stick did not break so easily.

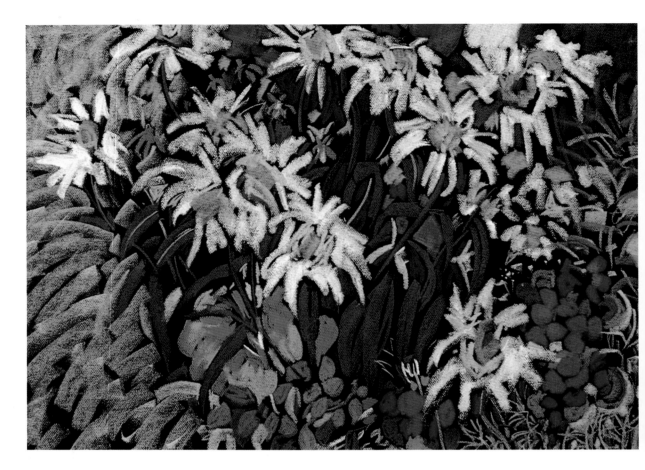

Charcoal is made from wood burnt in the absence of oxygen. It is very delicate and can be easily erased with a putty rubber or cotton wool. Care must be taken not to blend it with very soft pastel, otherwise the tints will blacken. With a minute gap of white paper between each colour the charcoal outline image will add sparkle to a composition.

It is necessary always to use fixative after working in charcoal, but this must be done very gently, as it is possible to blow the entire line sketch away unless it has been thoroughly rubbed into the paper, either with fingertips or a tortillon – a pencil-shaped tight roll of paper or cotton wool.

GRADES OF PASTEL

Pastels are graded by manufacturers according to the light or dark tonal range of each pure, unadulterated, colour. Asterisks placed next to the codes denote light fastness and permanence. Every pure colour has a range of light or dark

ABOVE **'Daisies with Geranium'** 21½x29½in (54.5x75cm). Soft pastel.

tones; green has many tonal gradations; and soft pastels have many more tones, or shades, than hard chalks. These tonal ranges are indicated by a number system usually printed on the tissue paper wrapped around each pastel. Unfortunately, due to the lack of standardization, the codes vary between manufacturers and it is very easy to tear or mislay the tissue wrap once it is pulled back.

I have disciplined myself into keeping back small pieces of favourite pastels which are then permanently stored in a match box with the code and colour name printed outside. If you can't be bothered to do this, it may be easier to take a small sample piece of paper with the colour tint fixed on, but remember fixative alters the tone of your pastels so you may not get a perfect colour match.

Good art shops usually provide test pads for their customers, but bear in mind that individual

pastels appear to change colour when applied to different coloured surfaces. It is standard practice for art shops to display only white paper pads with which the customer can experiment, and the colour charts supplied by the manufacturers are also printed on white. You must try out your sample on the same coloured surface that you would normally use, so you should ask for it or bring your own.

Pastels can be bought individually or in mixed boxes. It may be cheaper for a beginner to start with a basic drawing kit and add further colours from ranges later. It will not matter if you mix different brands together but remember the names of individual colours, for instance vermilion red, may not be an accurate description of that colour from another brand.

BELOW '**Chrysanthemum Maze**' 22x24in (56x61cm). Soft pastel.
A certain form and pattern begins to take shape as I work my way through the painting.

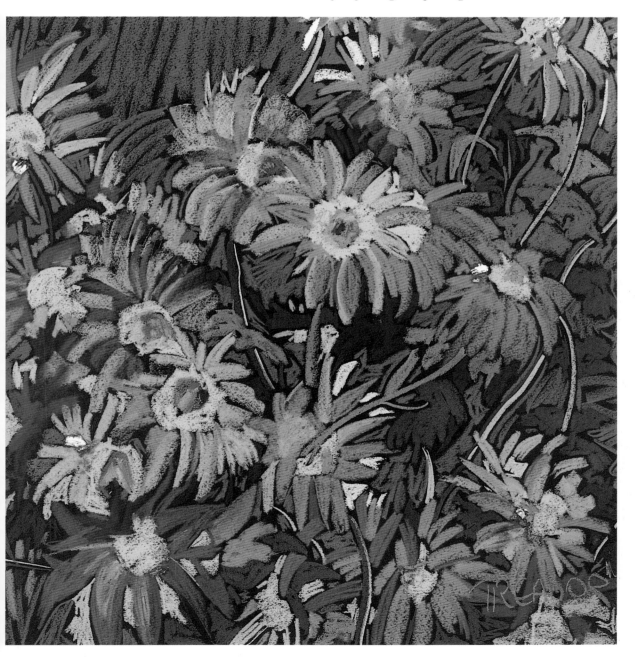

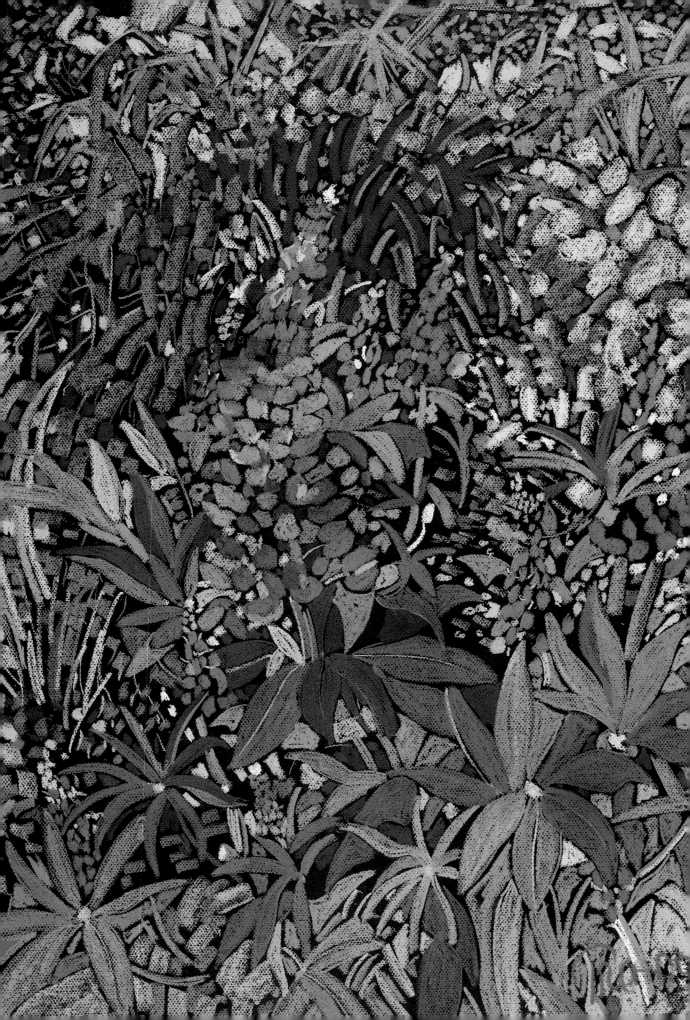

Chapter 2
SUPPORTS

· ·

PAPERS AND BOARDS

Ingres paper has traditionally been the support base most favoured by pastellists over the centuries and is still recommended today by paper manufacturers. Its lightweight, slightly flexed texture and muted tone subtly complement delicate powder pastel. Images drawn with sanguine or sepia Conté are greatly enhanced when the remaining part of the paper is left clear as background.

While I appreciate traditional pastel drawing, the overall effect is too sketchy and unfinished looking for my taste. This is a personal view, but one that is gaining momentum amongst other artists who regard pastel not as a prerequisite for some other more important painting medium such as oil paint, but see it as an end in itself.

If you want to transform pale pastel drawings into vibrant colour paintings, then you will need to experiment with heavier, rich-toned paper with more gripping power. It is not always possible to find suitable paper in art shops as the selection consists mainly of the natural earth tones, but slowly these papers are giving way to the deep dyes of viridian, black, royal blue and even bright orange. Canson's Mi-Teintes make a wonderful paper that is mounted on board, the grain of which plays a part in the overall design. If this interferes too much, then I suggest you try their unmounted paper, textured on both sides, but with one side smoother than the other.

Pastel can, of course, be applied to ordinary cartridge, sugar or parcel wrapping paper – even to carpet backing if you can find it. Some artists

LEFT **'Spring Flowers'** 32x23½in (81x59.5cm). *A secluded garden in Greenwich Royal Park.*

BELOW **'Roses'** 11x10in (28x25.5cm). Soft pastel on newsprint paper.

BELOW RIGHT **'Lily'** (detail) 8x8in (20.5x20.5cm). Soft pastel on light brown Ingres paper. *The complementary colours of yellow and purple are heightened by their close proximity.*

OVERLEAF **'Yellow Tulips in Greenwich Park'** 30x41½in (76x105.5cm). Soft pastel. *Rows of uniform, rigid tulips are planted in meticulous fashion in my local park.*

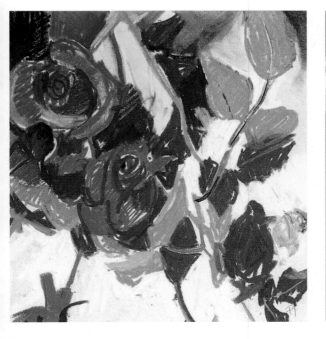

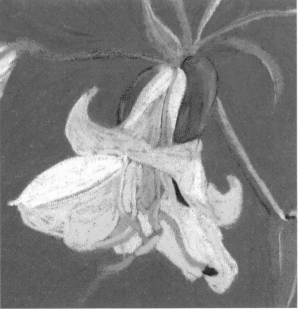

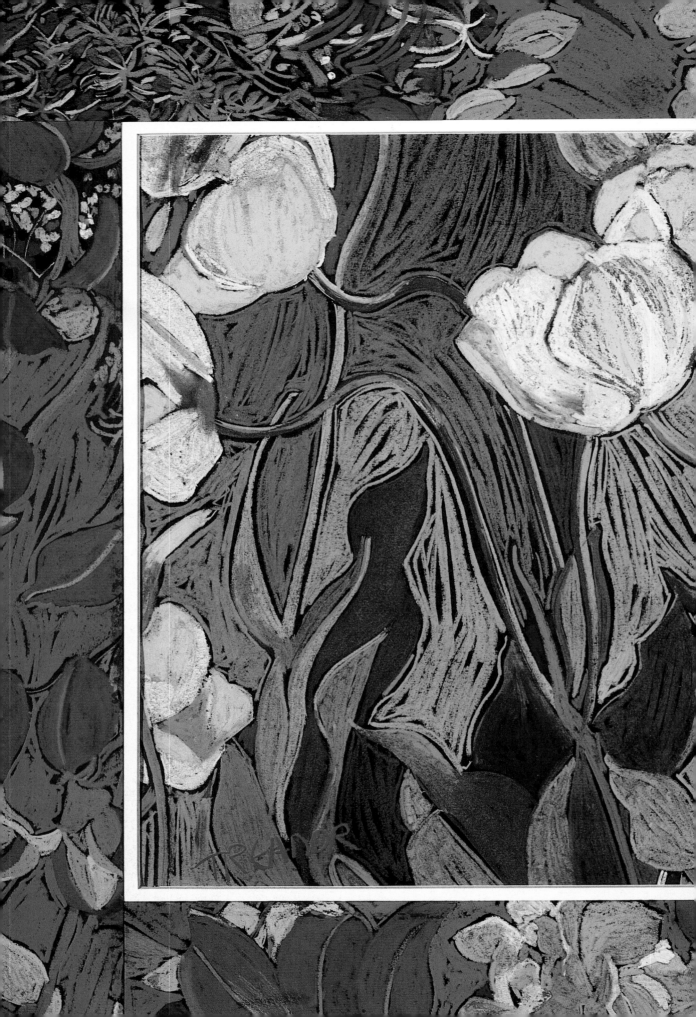

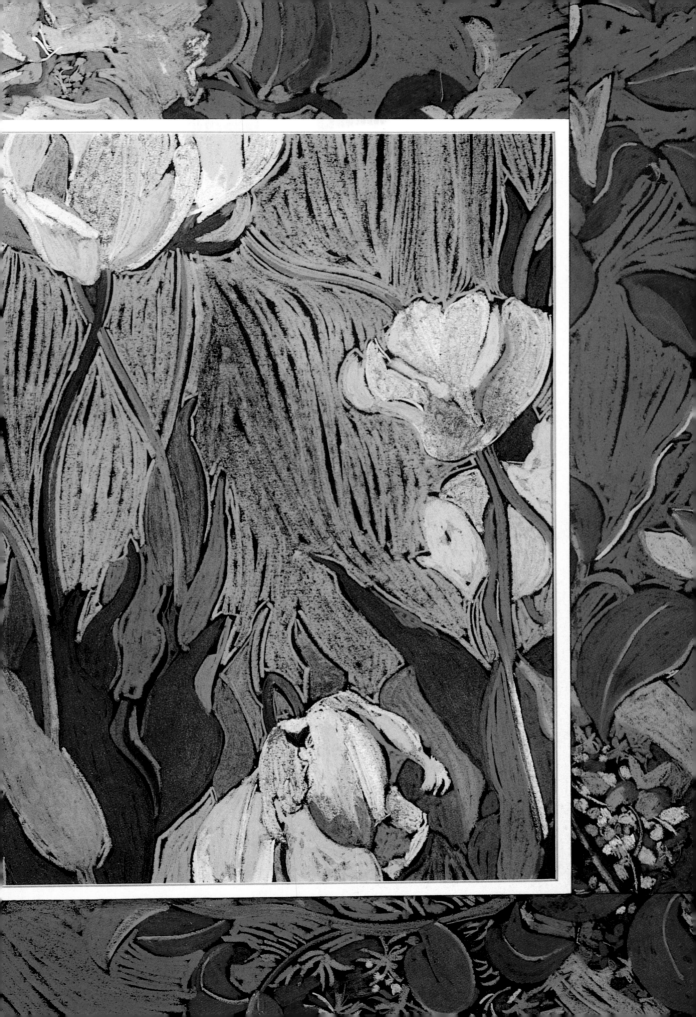

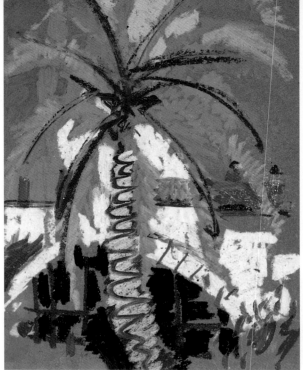

ABOVE **'Tulips'** 13x9in (33x22cm). Oil pastel on orange paper.

ABOVE **'Palm Tree and Bridge'** 14x9½in (35.5x24cm). Soft pastel on blue sugar paper.

are skilled in the use of glass paper in an attempt to avoid using fixative which may dull their pastel colours. An attractive, textured effect can be achieved by using large sheets of corrugated cardboard. Shiny, flat surfaces are not really suitable for soft powdered pastel because the pigment slides off, but oil pastel works very well, and positively glows on white. Much to my surprise, soft pastel pencils are excellent on Rexel Derwent ivory board pads. The smooth, hard, slightly shiny surface manages to hold pigment very well.

For those who enjoy blending, a more expensive velour is ideal. It is interesting that watercolour paper is now marketed as an alternative pastel support and the water-soluble nature of pastel pencil gives you a choice of leaving it wet or dry.

. .

SIZES AND SURFACES
. .

Unlike watercolour, pastel is often applied with vigorous arm movement. It is therefore imperative to work on a size that is not too small. I would recommend A4 upwards as the shape and width of most pastels are rather cumbersome, and if they break, as they so easily do, then the residual bits can be worked over or blended out away from the image. Too small a space limits

your arm movements and does not allow for much manoeuvring.

Before you actually start your work, check the tooth, or gripping power, of the paper with your fingers. It also helps to see which side is smooth or rough by holding it up to direct light – I have to admit I still make mistakes. Sometimes identification is made easier because one side caves in and is slightly ridged. The proper side to work with is the outer curve. You will be surprised at the difference one side makes to your pastel, especially with Mi-Teintes or Fabriano; both resemble canvas in texture.

Some soft pastel is so sensitive to surfaces when forcefully applied that it is apt to take up the impression of the underlying support. Rubbing, or frottage as this technique is known, sometimes is an unwelcome intrusion. I have been caught out unexpectedly with a sharp ridge running through the entire length of my composition. The fault was due to my pastel pressing on to the centre fold of a fully spread out double newspaper sheet. A large, heavy-duty sheet of wrapping paper firmly secured at the edges with masking tape is now permanently secured to my drawing board to correct this problem. I keep it clean with a damp cloth or vacuum cleaner.

The more 'give' the support board has, the better result you will have from your pastels. Never work, if possible, on hard surfaces: com-

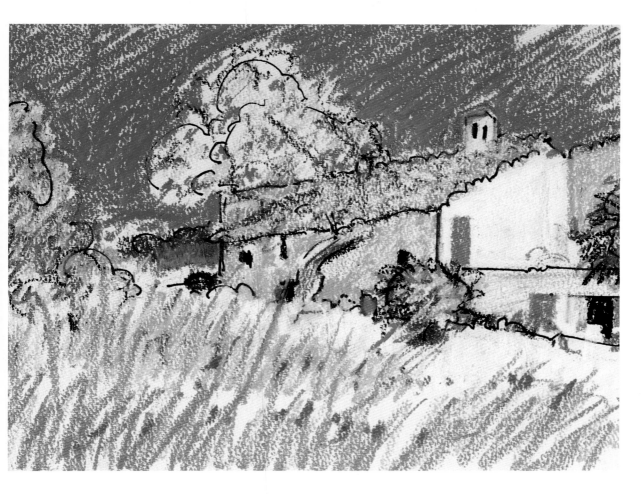

ABOVE '**Spanish Villa**' 15x11in (38x28cm). Oil pastel on rough surface watercolour paper.
The textured grains of the paper are allowed to show through by using the frottage technique.

pressed sheets of cardboard are excellent cheap substitutes for a wooden drawing board. Remember to stick carpet tape to all four edges in order to stop fraying and it should then give you many years' use. I have three such boards: one elephant-size, a smaller A2 and an A4. It is important to make the boards larger than your paper in order not to hinder the flow of your hand or arm movements while working. Should marks drift on to the outer sheet, they can be fixed or wiped away. When the build-up becomes too thick, simply replace the under-cover paper. I vacuum residual chalk-dust off my surfaces, between every painting session. This

way, my paper stays clean. Naturally, I take care not to place the suction nozzle close to the painting.

Pastel paper is kept secure on a board either with masking tape, which is less likely to tear paper on removal, or dog-clips. Drawing pins are not recommended as they leave unsightly holes and will damage the wooden surface of expensive easel drawing boards.

Elsewhere in this book I have suggested that if you had not worked with pastels before, it may be worth trying them out on cheaper newsprint or wrapping paper to get the 'feel' of them. Do this only at first, however, as this practice is inadvisable as your art work progresses. Pastel responds so diversely according to the surface on which it is applied that you may unwittingly blame shoddy art work on your pastels, or, worse still, on yourself.

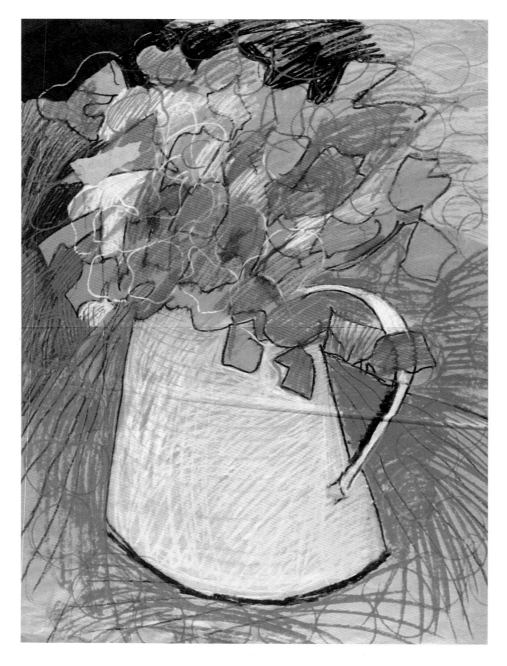

Cheap, poor quality papers are also not acid-free and will rot down eventually, leaving edges frayed. You might find it useful to make up a small sketch pad from odd bits of paper, which you can fill with rough working drawings before attempting your final composition on superior pastel paper or pastel mount board.

Different papers with varied textures and colour tones bring out unexpected reactions in pastel. At times I find this very frustrating, especially if I am short of time whilst working out of

ABOVE **'Sweet Pea'** 45x36in (114.5x91.5cm). Mixed pastel on parcel wrapping paper.

RIGHT **'Tribute to Picasso with Magnolias'** 33x23in (84x58.5cm). Oil pastel.
A memorial set up in a studio on the day the artist Pablo Picasso died.

doors or on holiday. I tend to stick to what I know from experience works well for me and I would encourage you to try out many surfaces before you do the same.

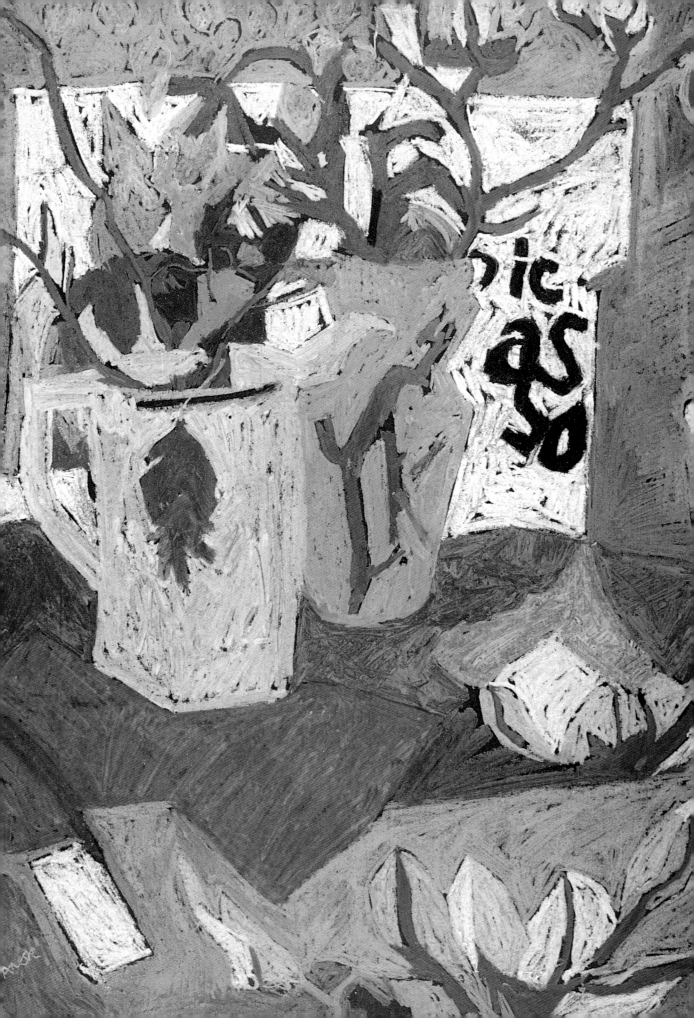

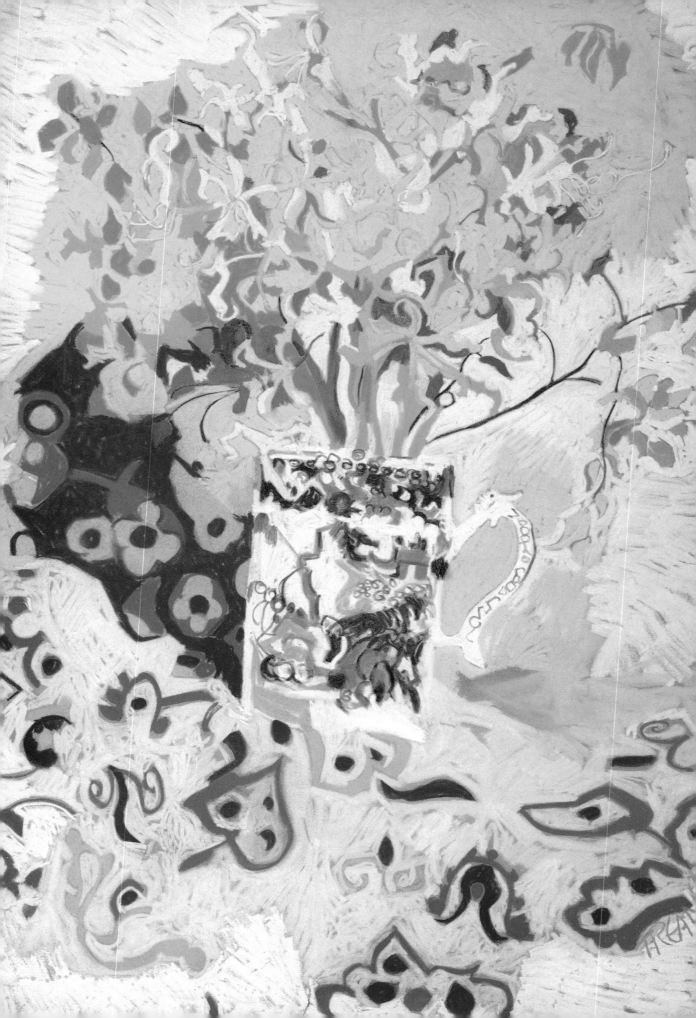

Chapter 3
PASTEL PAINTING AND DRAWING TECHNIQUES

. .

APPLYING PASTEL

I was already a fully qualified graduate in art before I discovered pastel. As a medium it was not taught in art school as it had been in the nineteenth century, when drawing was a compulsory subject. During the last decade it has grown enormously in popularity and there is much literature on the subject and practical advice in the form of workshops and demonstrations. It is, however, important to keep instructional rules in some perspective to allow your own creativity to shine through. Without realizing it, you may have already used many of the techniques of pastel in your own art works.

BLENDING
. .

Blending is still the most popular technique, especially with beginners, for it is a very simple, if somewhat messy, way of filling in large empty spaces quickly either with fingers or tortillon – a tight roll of paper or cotton wool shaped like a pencil which can be kept clean by unwrapping it

LEFT **'Orchids in Oriental Jug'**
32x23in (81x58.5cm). Soft pastel.
The gentle application of muted soft pastels on grey sugar paper gives an impression of blending.

RIGHT **'Peony'**
33x23½in (84x59.5cm). Soft pastel on grey sugar paper.
In this composition the soft pastel blended background subtly echoes the pink hues of the principal flower feature.

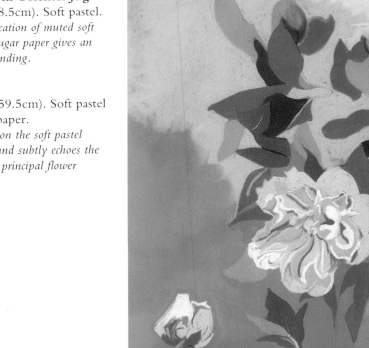

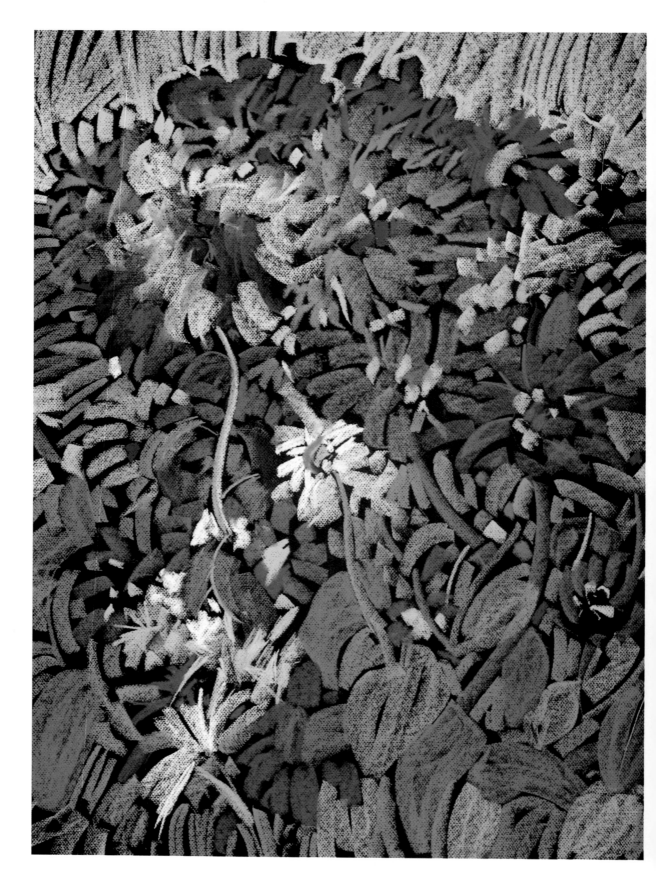

from its tip, or with a pencil sharpener. Some pastellists are skilled at blending with a brush, usually made of hog hair or synthetic bristle.

Greater control in smaller areas can be achieved by using the tip of a stump or tortillon on its side for wider sections. Personally, I never use these aids, although on occasion I must admit to using cheaper cotton-wool buds bought from my local chemist. I use them very sparingly – too much diffuses colour pigment and allows the paper's surface to intrude. However, this technique used intelligently can create atmospheric impressions of great beauty. If you decide that blending is for you, just remember not to overdo it or your pictures will look bland and sentimental in their uniformity of textures.

I rarely employ the smudging or blending method to my own work, but some flower petals are so delicate that their texture and colours can only truly be captured by blending very soft pastel such as Rowney soft pastel which have a superb range of tints.

BROKEN COLOUR

Whole colour areas using pastel strokes can give a drawing or painting an Impressionistic look. If these pigments are allowed to remain on a paper that has a strong grain surface without being smoothed or blended in, then these impressions will remain separated but unevenly distributed, giving character and texture. From a distance, the broken colour, as it is known, will appear to merge.

By turning a pastel on its side or by breaking a crayon in half, large tonal colour areas can be quickly covered. These initial impressions can be lightly fixed and worked over with the tip of a

LEFT '**Mixed Dahlias**'
31½x23½in (80x59.5cm). Soft pastel.
Using the flat edge of a semi-soft pastel it is possible to make striking colour combinations with the broken colour technique. The pastel has been allowed to remain on highly grained paper without being smoothed in. Therefore the colours remain bright and strong. From a distance the broken, uneven dots of colour appear to merge, giving the painting a bold, Impressionistic look.

ABOVE '**Villa in Provence**'
12x17in (30.5x43cm). Oil pastel on blue Ingres paper.
This small sketch is a particular favourite of mine. I applied extra chunks of oil pastel using the broken colour technique to the leaves of the tree with my fingers, which created an impasto effect.

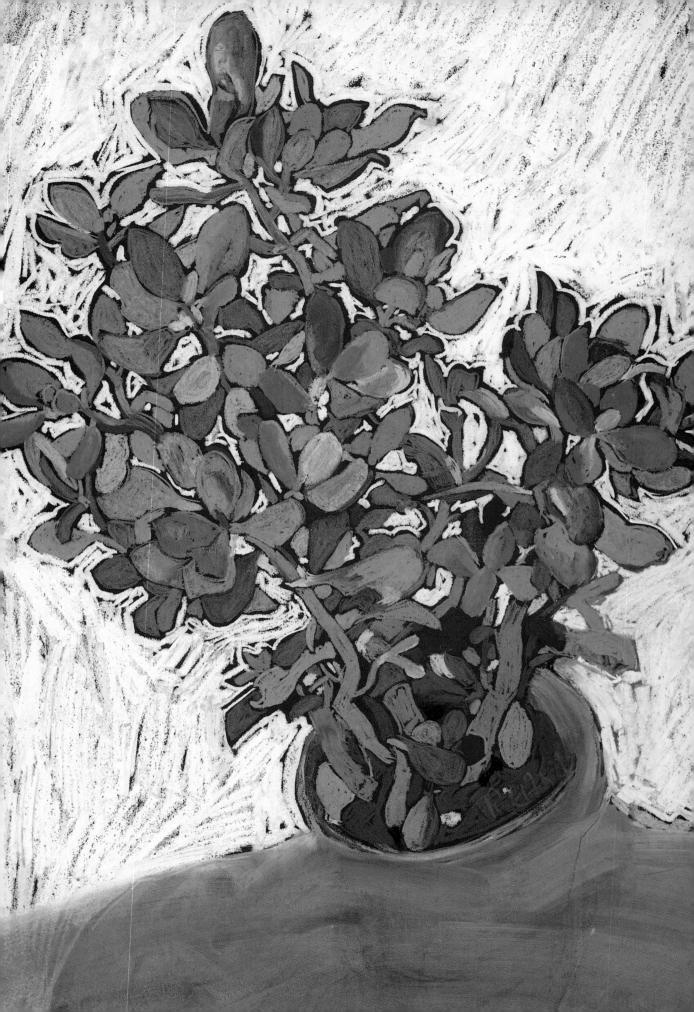

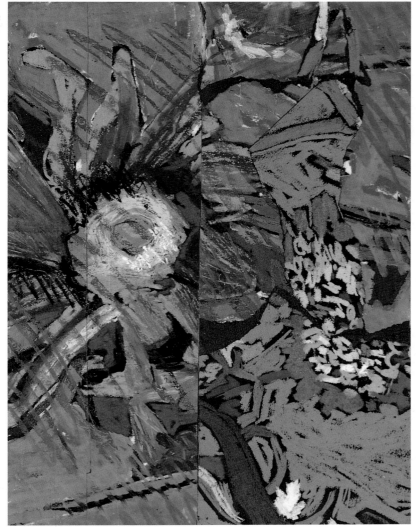

LEFT **'Crassula'**
28x22in (71x56cm). Oil pastel and turpentine.
The money plant, as this succulent plant is known, is extremely easy to propagate but its leaves fall off too readily if not watered regularly. This sturdy specimen was painted in oil pastel. The chalk with oil pastel applied to the pot, was later partially removed by dragging a rag soaked in turps across the base (sfumato).

RIGHT **Collage on paper and board** 14x10½in (35.5x26.5cm).
Using a mixture of techniques: featuring, hatching, sgraffito, impasto, blending and broken colour.

pastel in one or two colours at a later stage in the painting.

Some pastellists prefer to leave their backgrounds with a 'soft' look, using smudged or blended strokes. In this way they hope to create a greater sense of distance. The foreground is heightened by using bolder linear strokes.

BLOCK

Over the years, I have developed my own technique of using pastel in block form, which covers entire areas in solid colour that fails to distinguish boundaries between the background or foreground. This semi-abstract expressionistic approach emphasizes both colour and shape, as well as drawing attention to the pattern rhythm in the composition. I also use a more complicated technique whereby I combine block colour with linear strokes of colour. My mode of application is always determined by the subject matter, materials and choice of paper. Canson Mi-Teintes paper has a grained canvas surface which lends itself well to the way I work, especially if I want to use pastel on its side with bold, directional strokes.

IMPASTO

For years I worked on large, heavy 140lb (300 gsm) sheets of paper which had a smooth surface that reacted well to my Rembrandt pastels, if they were applied at the tip. I was able to use most of my other chalks to varying degrees, but

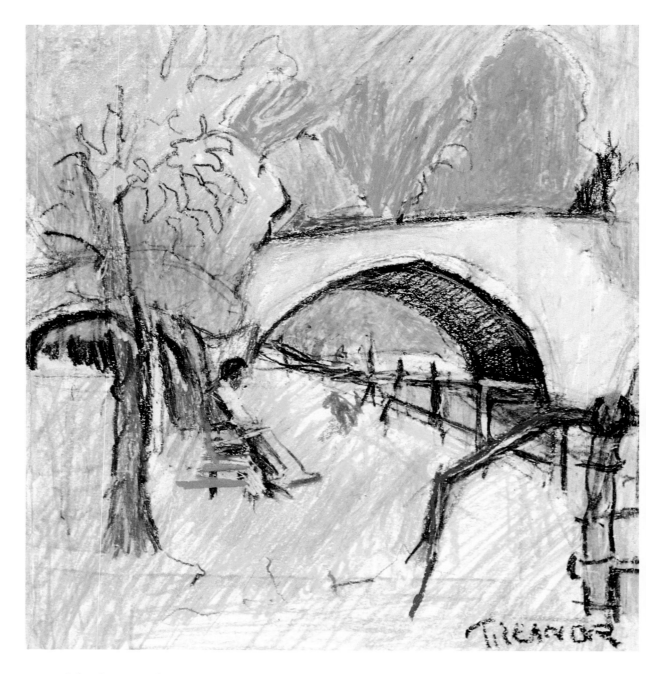

ABOVE **'The Quays with Figure, Clonmel'** 11x9½in (28x24cm). Oil pastel on white card.

it was hard work getting textured effects because of the lack of gripping power, or tooth, in the paper. I did, however, manage to achieve quite startling colour effects. The heavy weight of my paper enabled me to improvise without fear of tearing into the surface. I discovered that I could combine oil pastel with my soft powdered chalks, making them into a paste which glued itself on to layers of previously applied soft pastel. This technique, called impasto, is very effective if applied to the centre of a flower's head.

SFUMATO

On a small scale, I love working on white paper. I use a more gentle approach that could be described as *Sfumato*, an Italian word meaning smoke-like. The pastel is not blended but it has a hazy quality because the tones and colours melt

into each other, building up an image without a line definition of the actual subject matter so the overall image appears undefined. A quick way to achieve this effect is to wipe gently over any contour line with turpentine. Important details, perhaps lost through the overuse of this blending out method, can be redefined and heightened during the final stages to add points of interest (focal points).

SGRAFFITO

Another Italian term still popular today is the technique of scratching or *Sgraffito*. This method works well with oil or wax pastel as layer upon layer is built up in different colours. A sharp tool such as a knife – I prefer using a metal paper-clip with a smooth, rounded edge which does not tear into the paper – is dragged across the pastel in either a thick stroke or delicate scratch, revealing the underlayer of a prior application. This method works better if ensuing layers of pastel are allowed to dry for a few hours. It is important to wipe off any residual paste from your tool, if you want to avoid mixing the residue with any fresh application. Oil pastel dries to a hard paste if left to dry on a palette knife and white spirit or turpentine is necessary to scrape off the surplus pigment.

BELOW **'Tiger Lilies'** 25x29in (63.5x73.5cm). Soft pastel.
The background was applied using the rubbing, or frottage technique.

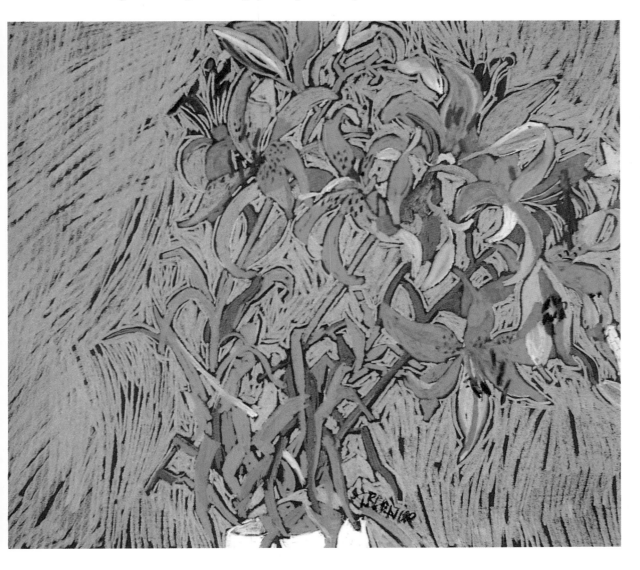

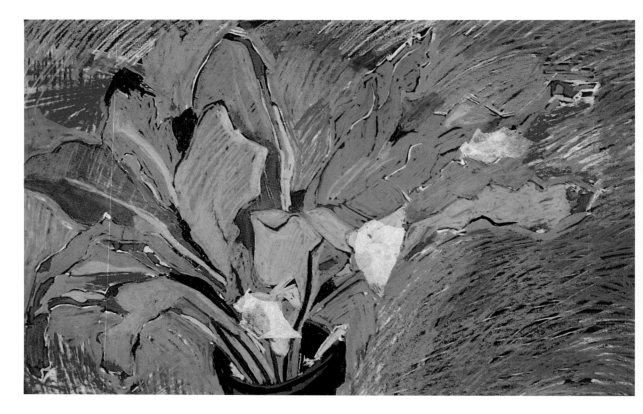

SCUMBLING

Scumbling is a method whereby one colour is dragged very lightly over another one without totally covering it. It is very important not to press the original colours too deeply into the paper at first, otherwise the fibres of the paper will block additional layers by becoming oversaturated. Usually one or two colours can be scumbled over the first layer but no more, or else the luminosity is lost and it will become bland. Smudging can be kept to a minimum by using 'workable' fixative.

It is worth experimenting with this technique because the end result is beautiful. Dark colours on light, and vice versa, work best. If the final layer can be left without fixing, the result is breathtaking. Unfortunately I find this impractical, as I often have to move my art work around for exhibitions or photographic sessions. Sometimes I resolve this problem by re-touching up finished paintings just before I glaze them. I've learnt to highlight in this method with care, because there is a great temptation to apply the scumbling colour all over the composition, thereby upsetting the former tonal weight and

balance. This dilemma has occurred when I have fixed a painting too thoroughly, leaving the colours to dry in duller tones. One way to avoid this is to scumble with a stronger, more vibrant colour perhaps from the Sennelier or Unison range of pastels. Their extra covering power counteracts the dulling effects of fixative.

HATCHING AND CROSSHATCHING

Hatching and crosshatching are marks of colour made with the tips of pastel or pastel pencil. The same colour is applied in a series of diagonal or cross strokes, normally spaced uniformly apart. Speed is important when using this technique, and after a while it is possible to develop an intuitive response to the actual direction which the hatched lines take. When I studied the art of illustration at art school, it was unfashionable to work in a crosshatch as it was feared that the art work would become overworked, contrived and predictable. One way to avoid this happening is to try a more subtle method of using the leftover ends of either hard or soft pastel. This creates a thicker, less regulated, uneven line which adds bite and a bit of character. Outdoor sketching is

LEFT '**Pink Aspidistra**' 25x38in (63.5x96.5cm). Pastel collage.
A rough, free description of a plant using oil pastel, chalk and soft tissue paper.

RIGHT '**Waterford**' 16½x7½in (42x19cm).
Watercolour with soft pastel in the foreground.

more unpredictable than studio work and forces an artist to make instant decisions, hopefully in a more intuitive way. Therefore hatching is an ideal technique to employ especially if you find your drawings are becoming somewhat monotonous.

FROTTAGE

Frottage is a rather funny and unusual word for a technique that I find extremely useful. At times I enjoy leaving my backgrounds clear and uncluttered but sometimes while working with one colour, a daunting feeling comes over me and the desire to continue with this hue suddenly dies. I've learnt to trust this gut feeling and stop the painting at this juncture. For I have been warned by my 'inner eye' that the area which I am trying to cover with a single colour has reached saturation point, and if I were to continue then the effect, or drama, of the colour would be reduced. This frequently happens if I choose to use a cool white as a background in a composition. The reason for this is because the delicate balance of harmony which exists between primaries or secondaries is quickly deadened by the overpowering absorption of white. Ways around this problem are either to add a small amount of yellow to white making it into an off-white, or better still to break up colour with a textured surface.

Frottage, or rubbing as it is otherwise known, can use up vast amounts of pigment but the results are very exciting. A simple and very effective way to cover an area texturally is to place a large piece of soft paper over corrugated cardboard and rub pastel, on its side, over the ridges. As the chalk breaks up over the bumps an uneven, irregular pattern will appear according to the pressure applied. Soft pastel breaks more easily but the response is better. Hard, flat strokes applied in the same direction give a more mechanical patterned effect.

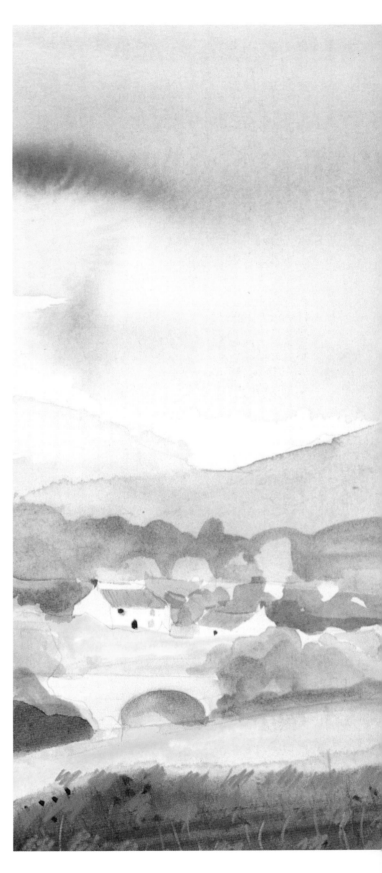

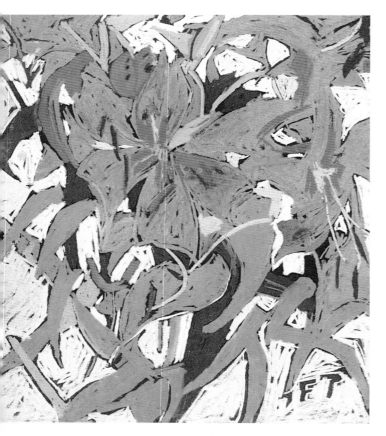

ABOVE '**Orange Lily on White**'
25x23in (63.5x58.5cm). Oil pastel.
The large orange flowers and the leaves of this stunning plant form a dramatic pattern against the white background.

Before you try this technique, it is important to have more than one sample of the exact colour shade you intend to use. If you run out midway, as I have done in the past, you will have to improvise with another colour of similar hue, or a different one altogether, which can look a bit untidy. The trick is to make your mistake look deliberate: this is easier if your composition is based around flowers with foliage, as all you have to do is add another leaf or two!

If you are feeling more adventurous with the frottage method, you might prefer to create pattern texture manually, without the aid of underlying surfaces. Just remember to keep the stroke simple: units such as a semicircle or asterisk work well. If your hand gets tired, try not to lift it off the point at which you are working. Instead hold the chalk firmly down on the paper and

swirl the paper towards you from another position and continue. Do not let your arm stretch across unfixed parts, otherwise the uniform pattern will be destroyed.

FEATHERING

A popular way of using pastel, feathering allows a variety of colour and paper tones to play a part. Very thin parallel lines are drawn across a surface in a diagonal direction which has previously been blended or blocked in with colour. The method works well in livening up dull patches in your work or covering up mistakes that have been carelessly drawn or overworked. Shadow effects are possible using feathering provided similar tones of one particular colour are used, for example pink on top of red.

DUSTING

A technique whereby minute particles of hard or soft pastel are shaved off with a blade directly on to a surface and gently pressed with a flat knife into the paper is called dusting. The pigment is so easily blown away at this stage it is easier to work with this method indoors with windows closed. The technique is a good way of recycling the pastel dust that accumulates at the foot of your easel.

USING FIXATIVE

Pastel fixative is a mixture of thinly diluted varnish made, normally, from casein, distilled water, ammonia and alcohol. It can be purchased in aerosol cans or bottles with a diffuser. Without fixative, soft pastel is likely to fall off paper, unless great care is taken in placing the pigment on to a responsive surface such as sand paper, which is then immediately put under glass for protection on completion of the work.

Fixative can dull or darken pastel pigment if the colour is pale or thinly applied, and for this reason some artists are reluctant to use it. Therefore it is important to follow the manufacturer's instructions when fixing.

I prefer to use spray out of doors or inside a well-ventilated room, wearing an industrial mask which can be purchased from my local builder's

BELOW *Fixative can alter the tone of a pastel tint and create a shadow effect.*

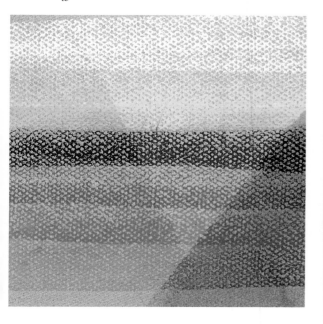

BELOW *Creating shadows with spray gold varnish using the dusting technique.*

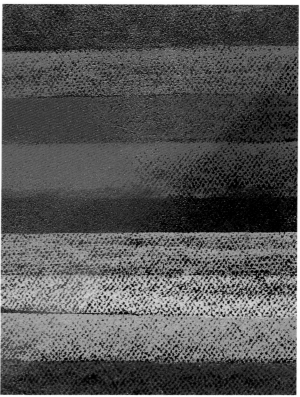

merchants or chemist. When I first used fixative, I sprayed small sections of my work very gently, with short bursts every few minutes. This prevented my chalk from falling down the paper while I actually painted. When the composition was finished, I then applied two or three coats of fixative over the entire piece at a distance of three or four feet, this time allowing each fix to dry thoroughly.

My easel is always in an upright position when I am painting and consequently, my soft pastels leave residual marks as they break and fall down my paper. Over the years, I have learnt to accept this and now realize that accidents can be incorporated into the overall design.

Pastel will adhere more readily to a surface which is placed horizontally. However, fixative should only be applied to paper that is placed vertically, otherwise there is a risk of spotting. Should this occur, try not to panic; instead, allow the fixative to dry and then camouflage your mistake by touching-up with new colour over the previous layer and re-fix from not too close a distance. Sometimes streaking occurs as the fixative combines with pastel pigment and runs down your paper. You may like to leave this or avoid the possibility altogether by placing your paper in a flat position immediately after fixing in the upright position.

One summer's afternoon, I became aware of the sun's strong rays as they filtered across my studio and danced on a still-life composition of flowers in a jug that I was in the process of painting. I don't usually put shadow into my work because I enjoy working with flat colour, but the visual effect was so dramatic that I wanted to include it in my composition.

I carefully studied the shadow movement made by the sun and noticed that it rested for a few seconds in more or less the same spot. I repositioned my paper so that these rays would fall on the paper. With a cut-out piece of thick card I waited for the sun-rays to reappear and immediately cordoned off the section with the card. Using three to four very forceful bursts of my fixative over the remaining uncovered area, I waited for the spray to dry. To my delight the fixative darkened the pastel pigment, leaving a ghost silhouette in its wake, which looked remarkably like shadow and what is more gave the impression of diligence and hard work! You might like to try this technique yourself.

HOW TO BEGIN IN PASTEL

CHOOSING YOUR MATERIALS

There are so many types of pastel around today that it can be confusing deciding exactly which brand to buy. At first, I would suggest that you avoid spending too much money on a giant box of pastels which may have colours that you will never want to use. Sometimes, basic pastel kits are packaged as 'landscape' or 'portrait' colours. I believe you, as an artist, should make up your own mind as to what landscape or portrait colours are, so would recommend buying a set of about twelve soft pastels and twelve oil pastels which contain all the primary colours – red, blue and yellow – plus black and white. A Conté à Paris basic sketching and drawing kit is useful, as it includes a putty eraser, stump, tortillon, sketching pencils and crayons, all in their traditional earth tones.

Pastel paper is expensive so beginners are better playing around with cheaper newsprint, wrapping paper or even beige-toned carpet-backing paper. Having got the feel of your chalks, you can then afford to buy the better acid-free pastel papers. An A2 cream cartridge pad will suit charcoal and Conté sticks. Grey Ingres Vidalon by Canson, size 11¾x16½in (30x42cm) or their pastel Mi-Teintes in assorted colours, size 9x12in (23x30.5cm) are very good for soft pastel. Oil pastels are easier to use on white paper with shiny surfaces.

FAMILIARIZATION

CIRCULAR SHAPES

A good way to familiarize yourself with pastel is to draw a circle very boldly on to a large size piece of white or cream cartridge paper. Do not think too much about the end results: concentrate on the circular rhythm of your arm. Any colour can be used in this exercise, but I would suggest you start with the flat edge of Conté crayon, perhaps sepia. Continue using a circular motion until the inner circle is full of chalk. Once this is done, using the palm of your hand, smooth out thoroughly. Now pick up a second

LEFT **'Red Hot Pokers'** 36x29in (91.5x73.5cm).
Soft pastel.
The tall and powerful, sinuous stalks of these flowers are quite alarming in size.

ABOVE **'Rustic Charm'** 30x21½in (76x54.5cm).
Soft pastel.
Mixed bunches of dried flowers look superb in old wicker baskets.

Conté crayon (sanguine or bistre), but this time use the tip end of the crayon and draw lines from the centre across the circle and out towards the outer edge. Repeat the exercise again, only now you may use stronger primary colour.

PROJECT: HORSE-CHESTNUT

If reference is made to natural circular shapes such as horse-chestnut or conkers while you work, very soon your circles will resemble their shape and colour without recourse to too much drawing. As more colours are added to the circle from a mixture of hard, soft and oil pastel and pastel pencils, juxtapositions of colour will emerge. You will notice that some colours blend easily because their pigment does not form a resist, for example soft pastel will not glide smoothly over oil pastel. Sometimes the colours will disappear into one another through their continuous build-up because there is a limit to the amount of oil pastel that can be applied before it becomes a sickly paste. If this happens, then a razor blade or knife edge can be used to scrape off the top layer, revealing a myriad of underlying tones. Ordinary fixative used between layers of soft pastel will eventually hard-en the pigment and darken the colours. Working fixative, sparingly used, should make multiple overlayering possible, but it is wise to avoid spraying in an enclosed area. Sometimes vigorous wildcat strokes will drag an existing colour slightly away from its original position, leaving an attractive residue in its wake.

It is important to draw with great speed throughout this exercise, but you must bear in mind at all times that the aim is to make a working drawing from which you may learn further, based on a circular line with undertones of smooth, flat shapes. If you choose to use natural objects as reference, remember not to get too involved at this stage in their structure or proportion, otherwise the spontaneity will go and you will become self-conscious and inhibited as your work slows down.

PROJECT: CONKERS

Autumn is a fabulous time to seek out exciting shapes from which to work. Conkers, with their shiny smooth surface, are a lovely source of

ABOVE **Conker**
Conkers, with their shiny smooth surface, are a good source of inspiration for working with a limited palette of tertiary browns.

LEFT **Horse-chestnut**
If reference is made to natural circular shapes, such as a horse-chestnut, it will be easier for you to draw your own circles with greater accuracy. As more colours are added to the circle from a mixture of assorted pastels, juxtapositions of colour will emerge.

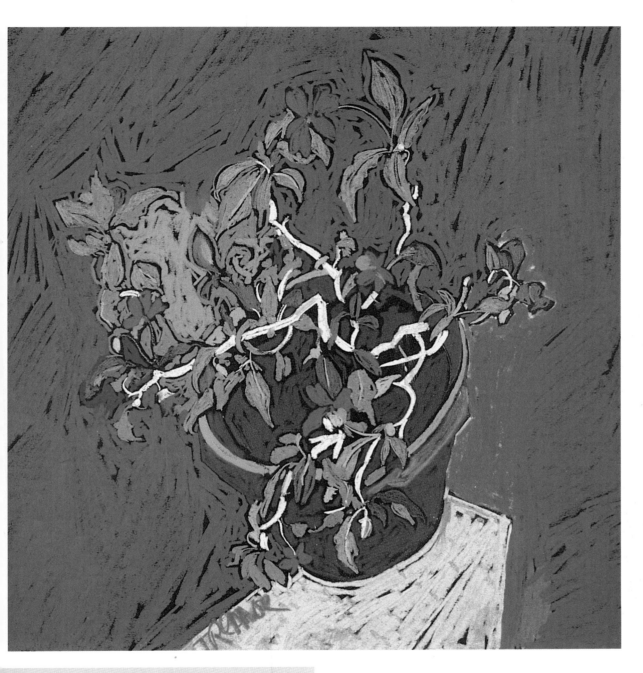

inspiration. Once again, using a limited palette of tertiary browns, practise your circular strokes of undulating contours, only this time pay a little more attention to the directional lines on the conker's outer surface. Notice how the external contour lines synchronize with your vigorous arm movement. Because of all the energy involved in carrying out these warming–up exercises, it is best to work on a flat table while standing, which should prevent too much pigment from falling off the paper.

ABOVE **'Busy Lizzie on Blue Table'** 22x24in (56x61cm). Soft pastel.

I hope that you will be pleasantly surprised at the interesting effects achieved when you make your first preliminary drawings. If you are dissatisfied, don't throw them away; keep them for reference until you are more experienced and can appreciate your early attempts for what they are.

Obviously, good drawing is an important aspect of pastel painting due to its tactile nature,

but I urge you not to try to make your drawings too realistic too soon, otherwise you will become over-critical of your own work, especially if you judge yourself against your contemporaries. It is your own interpretation that really matters, not what others think of your work.

Of course, mistakes are made and, on white paper, they sing out loudly. Forget all about erasing mistakes with putty rubbers or bread-crumbs: these are working drawings, and progress will only be possible if faults are allowed to happen. You are not in competition with

LEFT **'Marigold with Red Hot Pokers'** 32x44in (81x112cm). Soft pastel.
African marigolds are lovely to paint with their thick easily discernible leaves.

knocked people over. However, you can (and should) push your drawing to the limit, without being afraid of serious accident, and your skills will improve more rapidly as a result.

Never attempt analytical composition work until you understand your materials. If accidents in a drawing look like a representational image, then make a mental note, if possible, of the technique that made it. Content yourself at this early stage with the sheer joy of experimentation. In other words, become an abstract-expressionist child again.

YOUR OWN INTERPRETATION

The urge to draw and paint representational, acceptable images is very strong in children of junior school age. Whereas their earlier paintings and drawings were proudly displayed on bedroom and kitchen walls, the competitive element seems to take over at puberty. An individual approach can unfortunately be easily trampled on by peer-group or adult pressure, as a child is made to conform to what is considered normal and correct. Teachers can also perhaps inadvertently play a part in dampening a child's spontaneity in an effort to show the child 'how to draw'.

There are many ways of seeing the world, and all are equally valid. The one that is right for you will be the one that you feel most comfortable with. I am at ease interpreting my visual world in a semi-realistic way. Although I enjoy the discipline of careful analysis, I can fully appreciate the freedom of primitive abstractionism. Working on a large scale helps me to reach this goal. Using unfamiliar material and not paying too much attention to the rules also loosens up my mind. Different subject matter or objects evoke different responses. The same object can alter radically if viewed from an unusual point. Interpreting subjects using mixed mediums can also alter perceptions very dramatically.

anyone else but yourself. Several attempts had to be made before I learned to drive a car – I would have learned more quickly and more confidently if I could have whizzed around at top speed crashing all the gears instead of being mindful of getting it right first time in case I

DRAWING GEOMETRIC SHAPES

If you are just beginning a journey through drawing, it helps to keep things simple, Cézanne believed that the world could be visually understood more easily if objects were reduced to basic geometric shapes. A simple way to practise this is actually to make five basic shapes – circle, square, rectangle, triangle and cylinder – from cut-out cardboard, or to find boxes, cartons and containers of packaging materials, so the next time you visit a supermarket, see what you can find. Commit these simple shapes to memory and then ask yourself when drawing, 'What am I really looking at? Is it round, straight, or at an angle? Which basic shape is it?' Once you have established answers to your questions, it will be safe to begin.

This style of drawing is known as objective analysis and you should always spend a few moments looking in this way before rushing into a drawing. A small sketch pad next to your pastel paper will help you decide on your answers. If practical, hold the cut-outs adjacent to the com-

ABOVE **'Asters'** 25x38in (63.5x96.5cm). Soft pastel. *I was able to use a variety of vibrant primary hues in this composition which created a spectacular splash of colour.*

position in order to determine the structure. Working with this method sends a clear message to the brain and mistakes are less likely to occur, for the hand needs to become the interpreting tool, as well as the eye. Sometimes, the mind gets in the way and interferes too much through years of conditioned response.

PROJECT: A PINE CONE

At first glance the numerous segments on the pine cone will appear complicated. You may think, as I did as a student, that the aim of plant drawing is to portray every section as accurately as possible without giving too much attention to the character of the plant. A botanist may be happy with this approach – as an artist, I prefer to draw with more love, giving all my flowers and plants a personality.

As your drawing continues, you will notice that there is a definite rhythm and pattern to the wedge-shaped segments as the fan-like shape of the cone is established. You can practise repeating the pattern until the pieces link up as a whole to form a larger cone shape.

I always look for this rhythm in the natural world, for without it, I believe my paintings would lack life and energy. The subtle, simple tonal variations in pine cones will help you to appreciate the difference between one shade, or tone, of colour compared with another. Pine cones are limited in their mainly brown colour range, which makes colour selection easier. Using the Conté crayons and pastel pencils from a drawing kit would be ideal. Try to outline the semicircular triangles first and fill in later with the edge of pastel or, as I prefer, build up from the centre, using the flat edge of the Conté crayons and work up and out towards the edge.

I never pay too much attention to the actual number of segments if they run into more than a dozen or so but, over the years, I seem to have developed a sixth sense which tells me exactly when I have put down enough in my composition.

PROJECT: A PINEAPPLE

A more ambitious project following from the study of pine cones would be a drawing based on a pineapple. There are great similarities between the two, only the latter has a very striking foliage tail, if the greengrocer hasn't got there first! Colours are more challenging to paint if the fruit is mature. The hue variations are fantastic, although perhaps a little complex. However, if you are not used to painting in colour, pine cones or pineapples will lead you nicely into it. As their tertiary tones gradually evolve into secondaries, you will learn to mix up many colour combinations without having to worry about the clashing of primary colours.

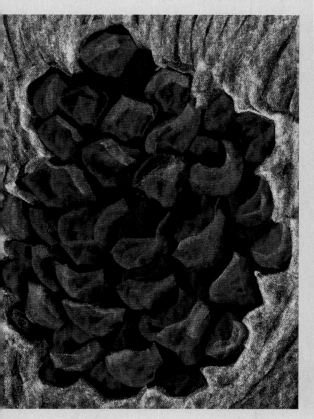

ABOVE **Pine cone painting**
There is a definite rhythm and pattern in the conical segments of a pine cone.

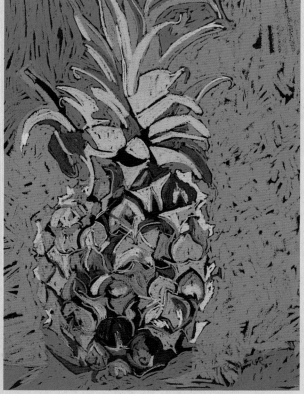

ABOVE **'Wally's Pineapple'** (detail) 30x23in (76x58.5cm). Oil pastel.
The overall impression is what matters here.

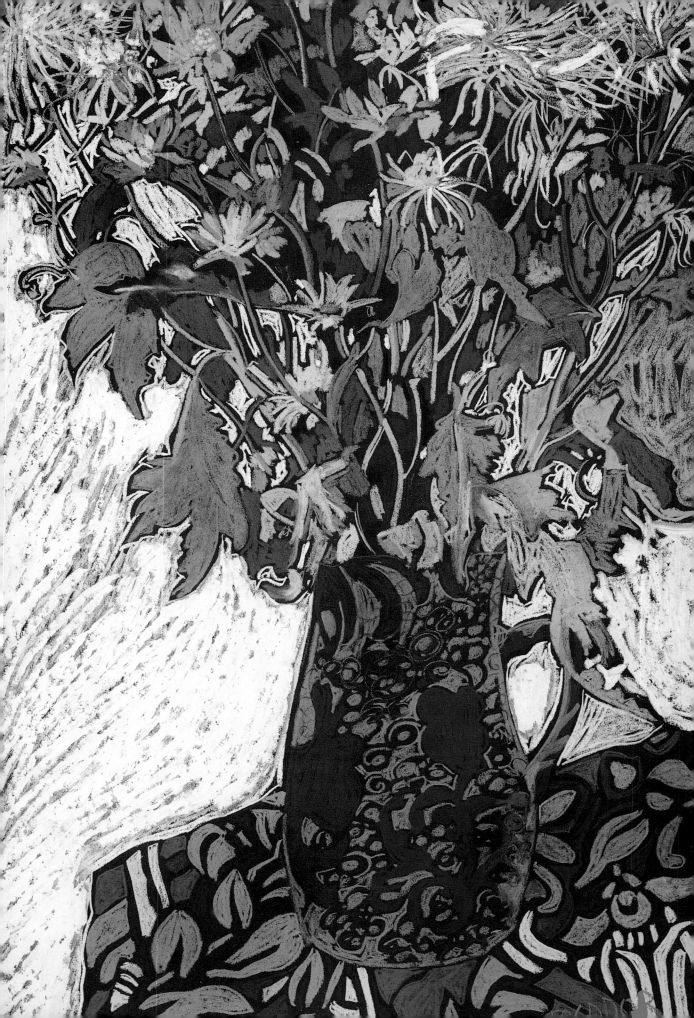

Chapter 5
COLOUR IN PASTEL

. .

UNDERSTANDING COLOUR

I am not fond of learning about colour theory through using endless colour charts and reading complicated texts, but the theory of colour analysis is extremely useful if you want to become a better painter. A more gentle way to learn about colour is from the natural world, where colour not only has a decorative appeal but is also functional. It is here that all the primary, secondary and tertiary hues work in harmony.

PRIMARIES, SECONDARIES, TERTIARIES

The three primary colours, yellow, red and blue, are sometimes referred to as basic or spectrum colours. Although these colours can be found in nature they cannot be made by mixing pigments. If all three pure primary pigments are mixed together they produce black.

The three secondary colours, orange, purple and green, are made by mixing the primaries together. Yellow and red make orange; red and blue make purple; and blue and yellow make green.

If a secondary colour is mixed with a primary colour it is known as an earth, or tertiary, colour. For example, yellow and orange make a yellow-orange; red and orange make a reddish-orange; and yellow and green make a yellow-green colour.

LEFT **'Alhambra Jug and Flowers'**
38x25in (96.5x63.5cm). Oil pastel and chalk.
Sensations of colour, pattern, form and texture exist in this composition. Flamboyant shapes of a mixed bunch of flowers have an almost tapestry quality which echoes the distorted pattern in the tablecloth and Spanish jug. The background has been treated in a more sombre manner with a thick impasto rendering of white oil pastel over grey Conté crayon. A background of white is the obvious choice of many artists but it is important to maintain a correct balance by limiting its use to selected areas, otherwise the tones of other colours will be drained and the brilliance of the white subdued.

TONAL COLOUR

I don't use much black or white in my paintings, but knowing that there are many variations between the two is beneficial. White is the lightest tone, and black the darkest, with variable shades of grey in between.

Drawing a pigeon's feather is a pleasant way of deciphering tonal variations. Better still, arrange a collection of dried flowers containing no primary colours. Select ten tertiary colours from your own pastel collection and paint the composition (my own interpretation can be seen on page 54). Alternatively, make a chart and see how far you can push your colours towards light or dark, adding white to make a lighter tone and black for a darker tone.

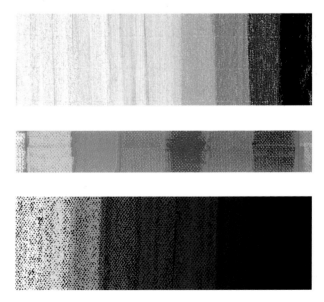

TOP Grey tonal chart in pastel on a scale of 1-8.

MIDDLE Monochromatic chart (different tones of the same colour) using Conté.

BOTTOM Light and dark contrasts of soft pastel tints (a colour plus white) and shades (a colour mixed with black).

PROJECT: AUTUMN LEAVES

To make a colour chart based on natural shapes which have similar colour tone, choose six large leaves, for example lime, sycamore, plane, horse-chestnut, maple. Dry them between newspapers weighted flat with telephone books or mirror glass. After a day or so, arrange the dried leaves on a plain white surface and gently outline in pastel pencil the overall silhouette of the leaves, overlapping where possible. Match the colour of each pastel as accurately as you are able, to every individual leaf; if a leaf has more than one colour, select the predominant one.

If you have not enough pastels to match, then improvise or mix them, remembering that pastel does not always mix well. Do not worry if you cannot get the precise colour mix: what really matters is that you become aware of the subtlety and range of tones in the autumnal leaves.

Using your pastel pencils or Carres Conté for the leaf veins, draw the linear lines without lifting the pencil off the line as you draw. Notice how the widths decrease as they flow to the outer edges. The function of the vein is to support as well as feed, as it spans its surface.

ABOVE **Autumn leaves project**
By matching pastel to the natural tones found in autumn leaves it is possible to build up a colour chart of secondary and tertiary colour.

THE COLOUR OF LEAVES

Leaves may look identical on the same tree at first, but after a while you will begin to appreciate their individual characteristics.

For quick sketches I portray leaves as a single pattern unit, ignoring detailed analysis. However, in my more representational paintings, this Impressionistic style gives way to careful observation and I may spend hours searching out the intricacies of a particular leaf. I am mesmerized by the gracious curves and sharp angles of foliage in the iris plant. I grow two special clumps in my garden. During the brief period when the flowers are blooming, I take all my Conté greens, Rembrandt, Rowney and Sennelier yellows and purples into the garden, come rain or shine. I never seem to have enough green in my palette to convey the variations in iris leaves. I am particularly fond of grey-green, as it does not shout too much. Searching for the brown, decaying tips eaten away by slugs or mites adds interest to the composition, as will a

ABOVE A quick impression based on autumnal colours.

broken leaf. Rotten leaves on the point of turning a bright lime-yellow at the base of an iris provide sparkle and focal points. A bit of yellow from the stamen in the head of the iris actually crossing the path of a purple petal will appear to glow, a colour reaction that occurs because the two colours are complementary.

EXPLORING SECONDARY COLOURS IN FOLIAGE

Leaves grow in all shapes, sizes and textures, with what appears to be an endless variety of the colour green. Matching pastel to these colour hues presents quite a challenge, for although there are many manufactured pastel tints available in green, I have found that there never seems to be enough to satisfy my particular needs. To overcome this problem, I use ready-made soft powder pastel and oil pastel together from an assortment of brands, and if a shade of green cannot be equalled then I have learnt to mix up my own from yellows and blues.

ABOVE **'Autumn Silhouette'** (sketch)

BELOW **'African Queen Lily'** 25x35in (63.5x89cm). Soft pastel.

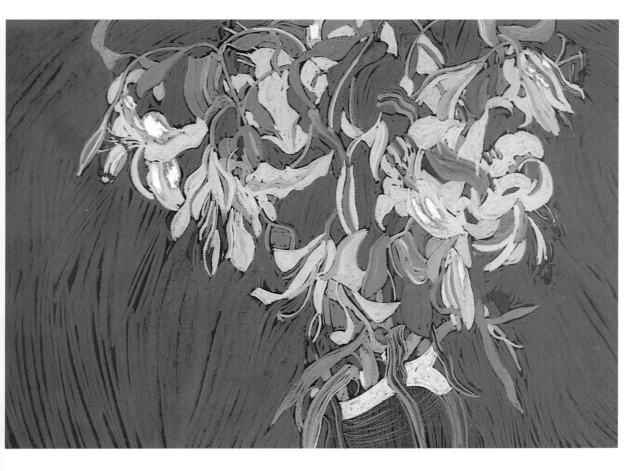

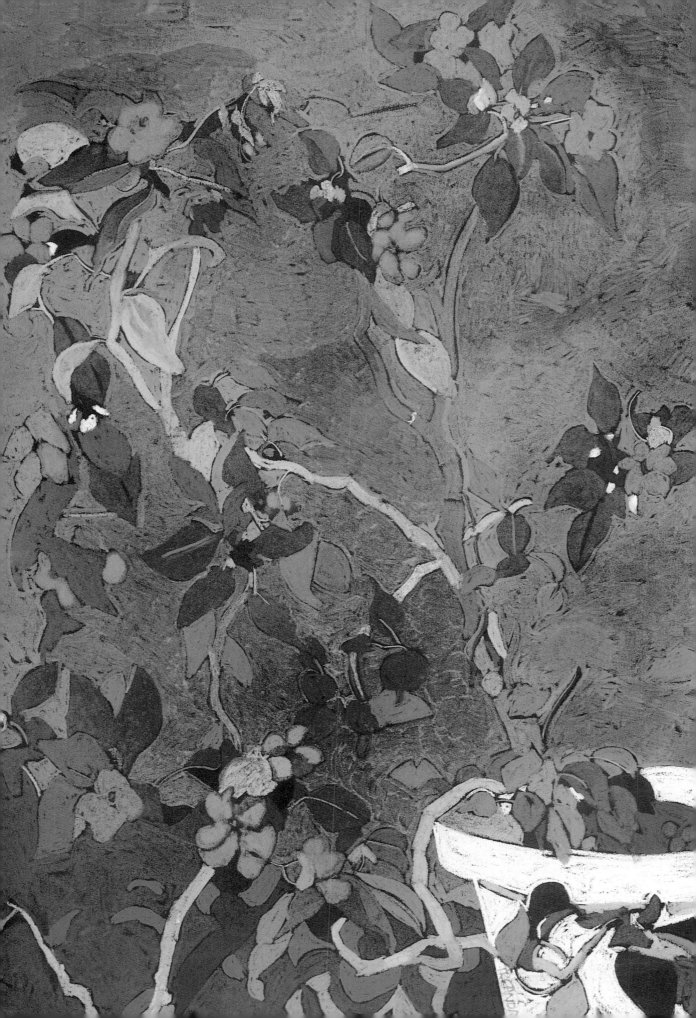

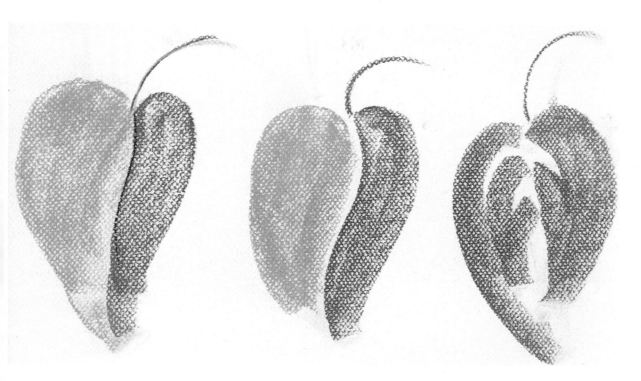

ABOVE Leaf detail 9x14½in (22x37cm).

RIGHT Leaf detail of geranium 11½x11½in (29x29cm).

LEFT **'Impatiens with White Bowl'** 33x23in (84x58.5cm).
The delicate shocking-pink petals have been created by applying a layer of soft Rowney pastel over a pre-fixed coat of red Conté chalk.

Care should be taken when mixing with different tints to record their names and code numbers, as they may be used repeatedly. It might be convenient to store them, temporarily, in a small bowl which can be kept close at hand as you paint so that it will be easier and quicker to colour in leaf patterns which have identical hues.

DRAWING LEAVES

Overall shape, colour and texture are important features when drawing leaves but it is not necessary to include every single item, unless it forms an integral part of the design as, for example, in the Swiss cheese plant *Monstera deliciosa* where the leaves are large and strong in their geometric shape and have a simplified vein structure. Smaller leaves with web-like veins running

through them can look unnatural and overworked if all their intricate details are recorded. However, the main vein which runs the entire length of a leaf will, if drawn, increase interest by giving a sense of direction and movement. One or two more delicate lateral veins may also be suggested in a manner which allows their lines gently to fade out, thereby focusing the onlooker's eye back on to the composition as a whole.

I have adopted three different approaches to drawing and painting a leaf: one – a leaf is left plain without any attention to details except for outline shape and colour; two – a leaf is drawn with only the addition of the main vein; and

RIGHT **'Monstera'** 38x26in (96.5x66cm). Oil pastel.

BELOW A cheese plant is an excellent model for analyzing basic geometric shapes.

three – a leaf is drawn with the main vein plus two or three minor veins.

Using the flat edge of a hard, chalk stick such as Carres Conté grey-green, a continuous thick line can be made provided the chalk is not lifted up from the paper at any stage. It is better to draw first from the top of the leaf and work down one side following its contour, leaving a thin gap on the inner edge of the leaf. Repeat the process for the other side of the leaf. The underlying surface should show, attractively, through this gap, giving an impression of the main vein. Alternatively, the gap can be filled in with pastel in a contrasting tone of light against dark.

In a more complex study of leaves where, for instance, the foliage intertwines, you should search for more in the plant, enjoying its labyrinth of patterns and rhythms, to convey the idea that plants are not mere botanical specimens but are a source of life, rich in wondrous colour, sensuous energy and personality.

PROJECT:
THE STUDY OF A FOLIAGE PLANT

Select the appropriate materials for your drawing – paper, pencils, ink, pastels, pastel pencils, charcoal.

Study a plant, for example a Swiss cheese plant, closely. Try to understand how the structure works. Look for the main lines of growth which spring from the central stem. Try to see the actual geometric shapes of the object.

Remember that although all leaves on the plant are similar they are not identical; each has its own individuality, shape and position in relation to the other leaves.

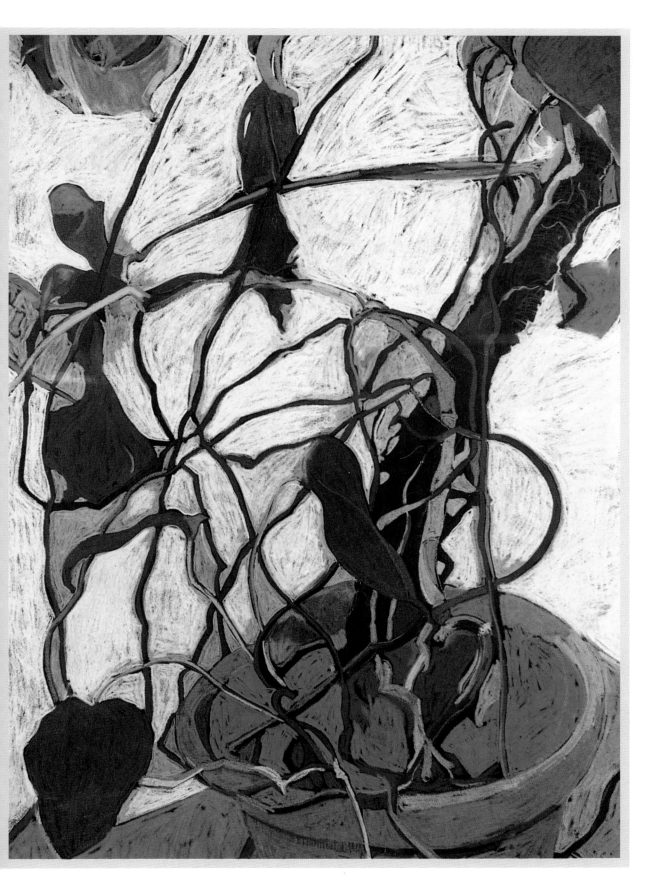

A COMPOSITION BASED ON DRIED FLOWERS USING TERTIARY COLOUR

It is more fulfilling developing your colour sense from nature, rather than taking recourse to complicated academic text books on colour theory. I hope to encourage you to draw with colour, working gradually through the spectrum from earth tones to vibrant primaries.

Tertiary colours, the outer hues of the colour wheel, are made from mixtures of primary and secondary colour and produce yellow-orange, red-orange and yellow-green.

By selecting varieties of dying foliage, you will be able to work with harmonious tertiary colours because most of the primary colours found in living flowers will have faded. I spent several months searching for the dried flowers and grasses in my 'Autumn' composition. Never sure if the plant, once picked, would dry intact, I did know that if I waited too long the weather might destroy its shape and texture. There are special ways to dry flowers and instruction can be found in books on floral arrangement. I am still learning by trial and error, which I think gives my arrangement a more natural look. I don't remove the leaves from the stems because I rather like the weird shape made as they dry upside down. It is a good idea, for drying and drawing purposes, to bunch the flowers according to their species, their colour values or their textures. Tie them with elastic bands or garden twine and hang them upside down in a dry, cool cupboard where they will not be disturbed for at least two weeks. If you're very artistic, it is possible to make beau-

RIGHT **'Autumn'** 24x32in (61x81cm). Pastel and pencil. *A composition based on dried flowers using tertiary colour. Dried flowers were arranged in an informal, asymmetrical style in this composition. Drawing with pastel pencils, I was able to explore, in great detail, the intricate mixes of tertiary colour. As a contrast, I used a single bold colour of viridian soft pastel for the background. Hints of violet from hydrangea heads blended subtly with the bright, delicate, orange Chinese lanterns. The more solid shapes of pine cones were created by applying the blunt points of brown pastel and Conté chalk over a blended soft pastel base. This technique was repeated in the firmer, crisper line of helichrysums.*

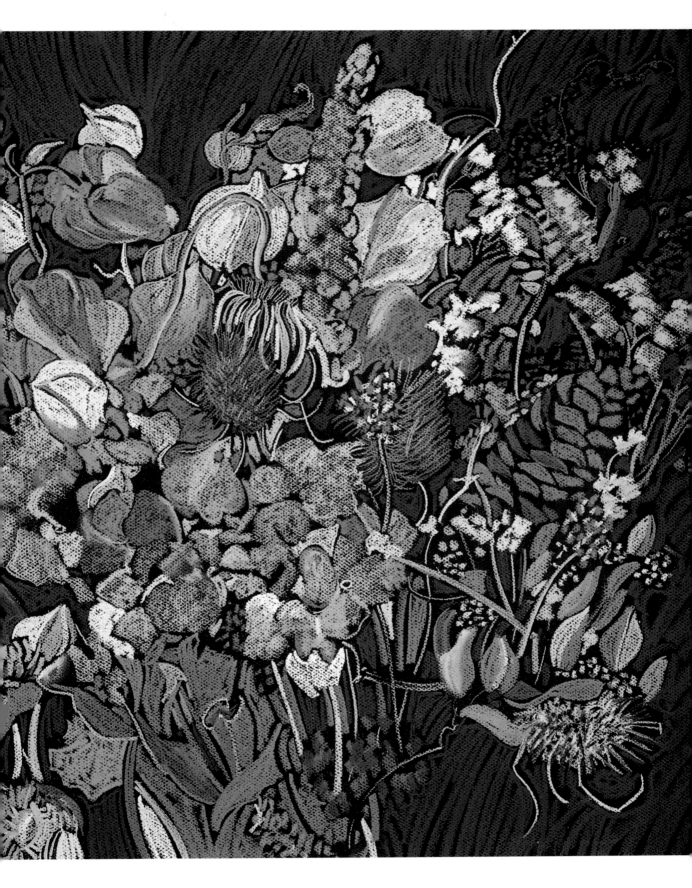

tiful arrangements of flowers which hang in rows of colours secured to bamboo sticks suspended from the ceiling. Only when the foliage is brittle and dry should it be taken down. Earthenware pots or terracotta jugs will also hold dried flowers beautifully. A scrunched-up piece of wire-netting inserted at the base of pots will keep the flowers in place for months.

Hydrangeas, Chinese lanterns (*Physalis alkekengi*), pine cones and honesty (*Lunaria annua*) all make excellent dried flower arrangements for painting. For a splash of colour, try strawflower (*Helichrysum bracteatum*): these are my favourites as I enjoy picking out their separately defined petals with a carefully matched Carres Conté stick.

For larger splashes of colour, try out Sennelier or Rembrandt pastel on its edge. The extra-soft pastel l'Ecu by Sennelier makes a rhododendron petal look like a gossamer wing.

GRASS

Patches of green grass in an outdoor painting or sketch will form the perfect neutral backdrop to a landscape rich in variegated texture and primary colour by unifying the whole scene, much the same way as a plain, white linen tablecloth complements cutlery and dishes on a dining-room table.

Primary hues, especially red, will be enhanced if placed next to green, so getting the propor-

BELOW 'Greenwich Park with Royal Observatory' 17x40in (43x101.5cm). Soft pastel.

tions right is important as the predominance of one colour may take the eye away from the main focal points. If this happens, a way to remedy it is to pick out some individual grass-blades from the overall mass with strong, directional lines using hard chalk on white paper or by superimposing oil pastel on top of a layer of powder pastel. Do not become too conscious or controlled in your eye and hand movements as you put in the various blades of grass, otherwise they will look stultified and dull. It is far better to add the grass at the final stage of your painting once you have decided where it must go. Choose the tone of green carefully before you make any mark as many good plant or landscape paintings have been ruined by the insensitive application of too bright a green. Now work as quickly as you are able because once you know which colour to use you can then forget about it and concentrate instead on building up areas to a crescendo by using short, rhythmic strokes.

Alternatively, you can fill the whole space in one go with the flat side of the biggest pastel you have. This method can give spectacular effects and save a lot of time. However, keep an eye open at all times for changes in the balance and relationship of your main subject matter, if any, as it may get a little lost if too vast an area of grass is applied.

In my own paintings, I like to keep my grass strokes simple with lines flowing more or less in the same direction, getting progressively wider as they reach the bottom of my paper. But if, on completion, I find that I have made my fore-

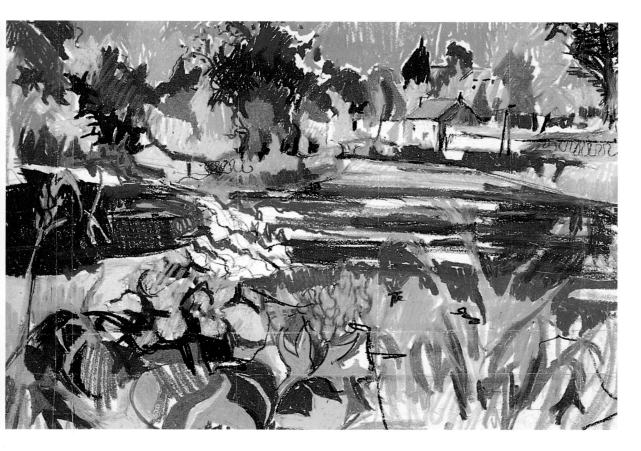

ABOVE **'The Weir, Clonmel'** 16x22½in (40.5x57cm). Oil pastel.

ground a little monotonous by the overuse of a single colour then I might add one or two, undetailed, colourful flower heads.

COLOUR AWARENESS

'Go for the primaries' would be my personal advice to anyone wishing to further their understanding of colour awareness. Until I went to art college, I never thought about colour as a subject in its own right. I can recall happy childhood memories at junior school when I mixed, with a gigantic wooden hog brush, lots of powder paint in jam-jars. If I wanted to lighten a colour, I was taught simply to add white or use yellow in order to make a corner of my painting brighter. I learnt that the leaves of trees were green, and the sky always blue! I was encouraged to outline all contours in black in order to make things really stand out. I also learnt that all shad-

ows were grey, and tree trunks looked rounder if a bit of grey was painted on the edge. I was so impressed with this revelation that from that moment on, all my trees had grey shadow running the entire length of every trunk, irrespective of their tone or light source.

In retrospect, it might have been wiser if I had been allowed to develop my own sense of colour. By the time I reached college, I had a built-in resistance to colour theory, and resented the seemingly endless Bauhaus colour charts which bore little or no relation to the world around me. This was made even more poignant on my journeys to and from college in inner-city commuter trains. As I looked out through grimy windows, the greyness of passing tower blocks only reinforced the impression of despair and colourless decay of the landscape.

I became acutely aware of the lack of pure primary colour in my urban environment. Fortunately, thanks to the patient perseverance of one young art lecturer, the terms objective analysis and complementary colour were drummed into my head, but several years were

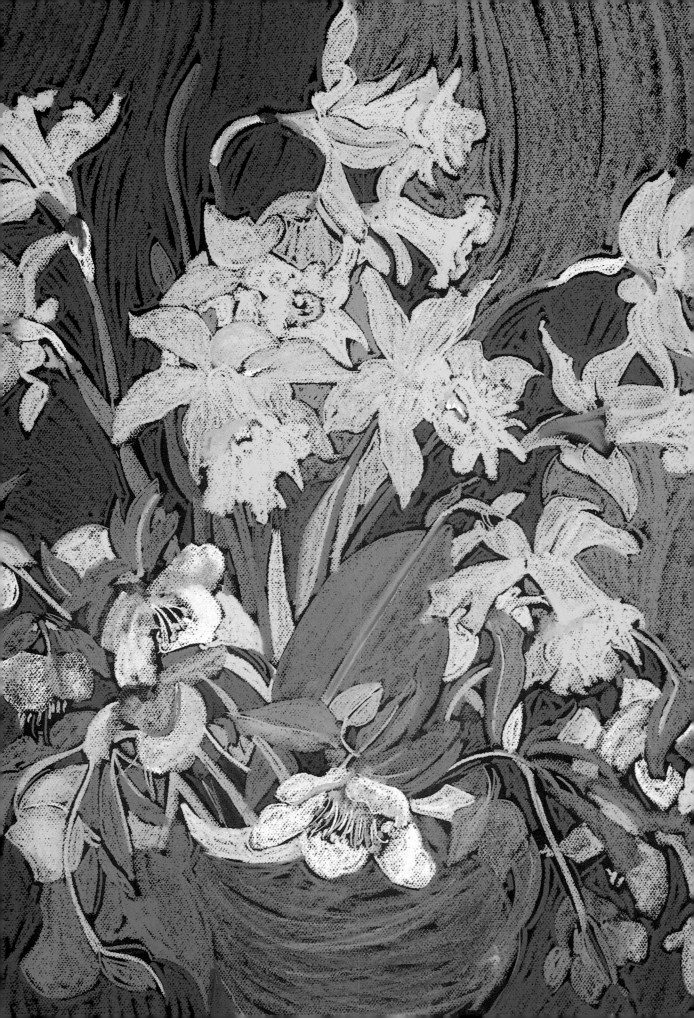

LEFT **'Daffodils with Jug'** 31½x23in (80x58.5cm). Soft pastel.
A flower composition in vibrant primary colours.

RIGHT **'Lupins and Daisies'** 29½ x21½in (75x54.5cm). Soft pastel.

OVER PAGE **'White Dahlias'** 25x38in (63.5x96.5cm). Soft pastel.
The interesting pattern on the jug with its deep purple and pale mauve hues is in direct competition with the white flowers and creates a striking contrast.

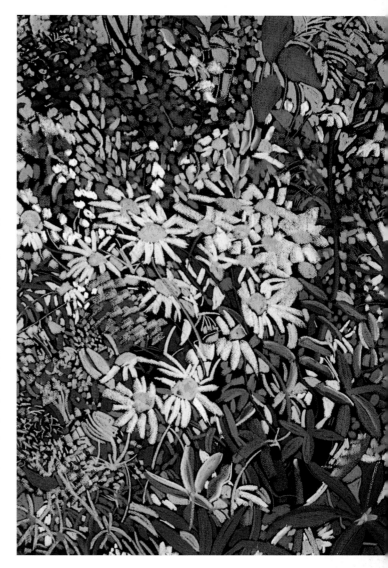

to elapse before I understood the true meaning of these words, and I'm still learning!

I would suggest that the knowledge gained from any colour exercises you attempt should be applied directly to your own work in conjunction with your own personal paintings. I use colour subjectively, in a personal, symbolic manner and objectively, in an analytical way with precise reference to the subject matter. Working directly from a natural source will make it far easier to find colours that relate to each other.

John Constable's landscapes caused an outcry in the early nineteenth century when he broke with Classical tradition by exhibiting pictures which were painted directly from nature. Prior to his work, genre painters were obliged to apply certain principles to their studies: Nature was depicted in a controlled manner and Mankind in the allegorical guise of a nymph. Using a limited palette, they applied pale blues to their backgrounds and browns to the foreground. Through the skilful deployment of red, Constable managed to draw the onlooker's eye towards a focal point. It was the use of this colour, combined with fierce brush strokes, that so inspired the French school of Impressionism. Red is such a powerful colour, especially when placed next to green – a secret well known to Mother Nature who uses it to her advantage in flower pollination.

Half a century or so later, the Dutch artist, Vincent Van Gogh embraced the Impressionist movement but later abandoned it in support of an Expressionist doctrine which favoured a more naive, emotional response to life. It is interesting to observe that the further south he travelled towards the sun, the more vivid his colour sense became.

During my stay one summer in the small village of St Remy, near Arles in the south of France, it became clear why Van Gogh changed his colours from a dreary palette of browns to the basic primary and complementary hues. The deep blue, cloudless summer skies of Provence juxtaposed against crisp, white walls and orange roof-tops with green, jagged olive groves are essays in themselves. No wonder he became so excited and feared that there was not enough time to capture all the wondrous colour that surrounded him.

I experienced a similar reaction in the most northern part of Scotland. Here, black oil derricks shimmered and glistened in the sun, like jewels, in the motionless sea that met flat plains of indigenous purple heather growing alongside artificially planted fields of bright-coloured,

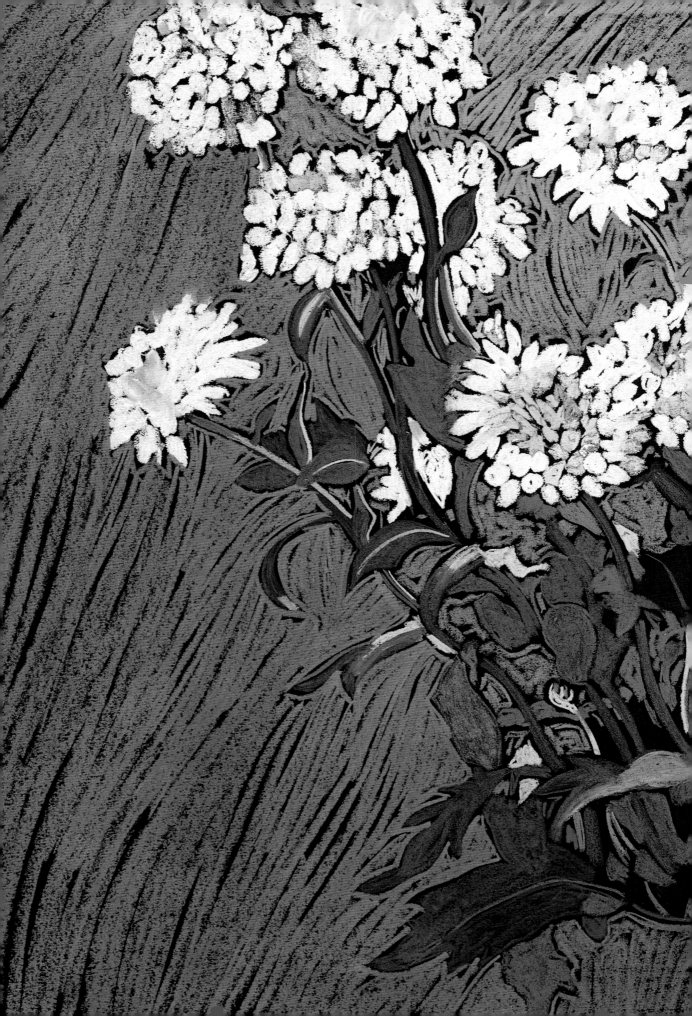

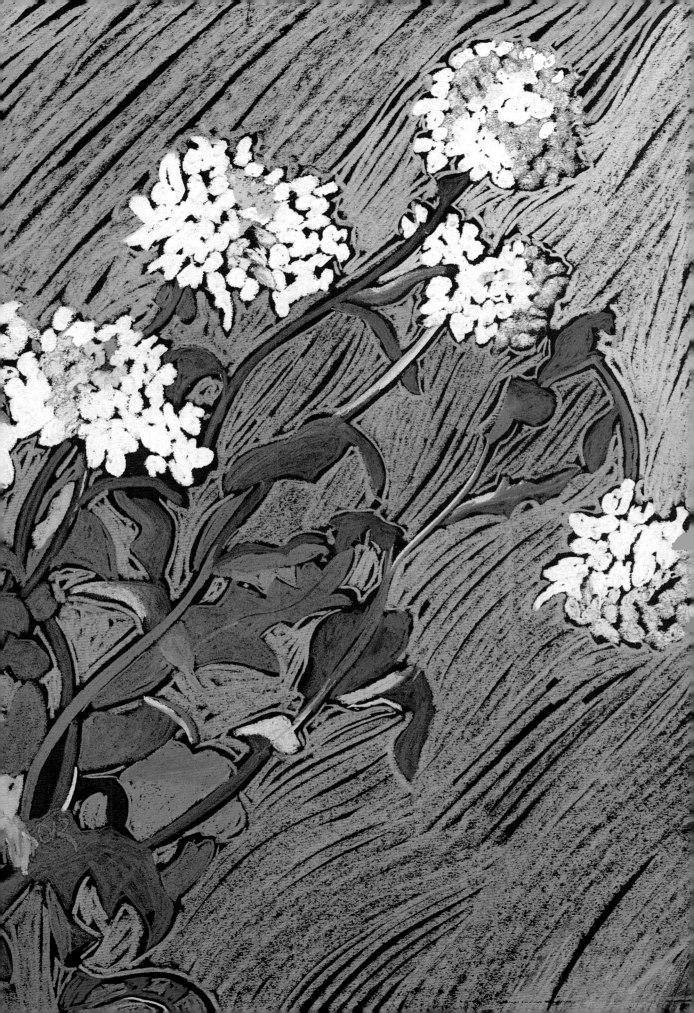

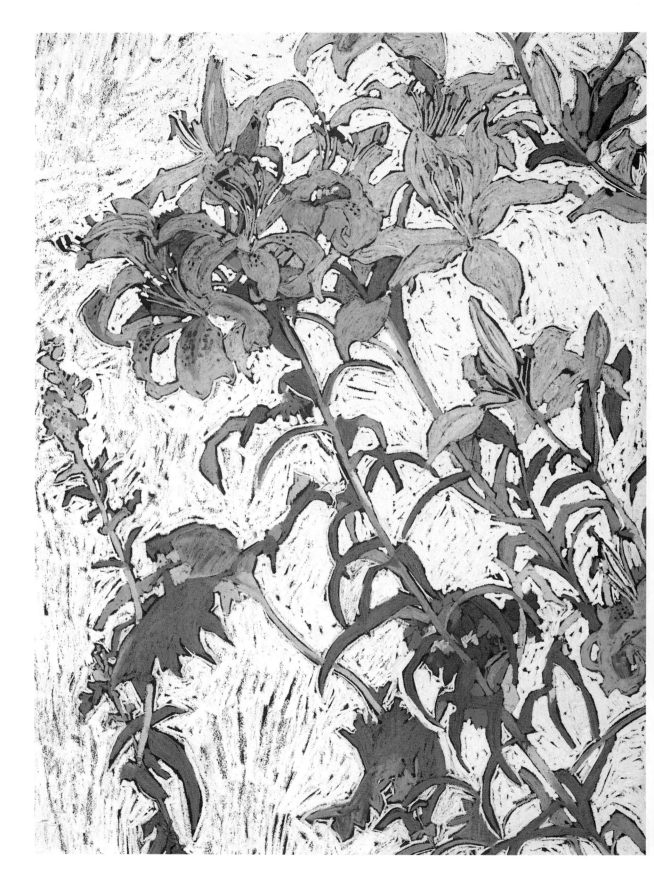

yellow rape-seed. I have come to the conclusion that unless one is surrounded, naturally, by bright, unadulterated colours, then it is an up-hill battle trying to conjure them up without the aid of a text book.

Pastel is available in an enormous range of tertiary shades and the name itself is synonymous with soft, pale colour tone. Because it lends itself well to the muted tones of a cooler climate, this

LEFT '**Maureen's Lilies**' 25x38in (63.5x96.5). Oil pastel and chalk study in orange and white.
Some time ago a neighbour asked me to keep an eye on her cat while she was on vacation, so while I had the keys I took the opportunity of painting in her garden.

BELOW '**Stargazer Lilies**' 21x26in (53x66cm). Soft pastel.
White will appear brighter if next to blue, but it can have a cooling effect on other colours.

may be the reason why pastel manufacturers pre-fer to market the product using subdued colour combinations on their package design. However, it is a different matter once the box is open!

I have learnt much about bold primary colour combinations by matching my pastels to the hues of cultivated flowers and about secondary colour through matching my greens to their foliage. By deliberately limiting my palette to half a dozen or so pigments, I forced myself to work within these restricted colour fields and so gradually became aware of the subtle relationship of one colour to another. Through eliminating shadow and searching only for the essence of a colour – a trick I picked up when lino-printing – I slowly became aware of basic colour even in dull light. If a particular colour was unavailable, I would substitute it with a near approximation, or better still, if I was feeling particularly adventurous,

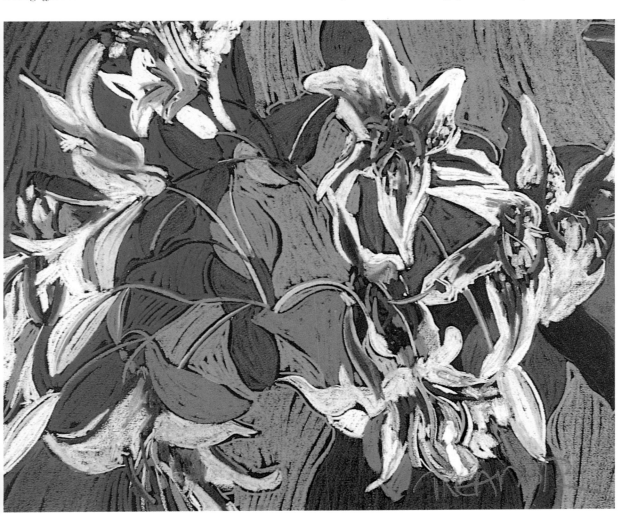

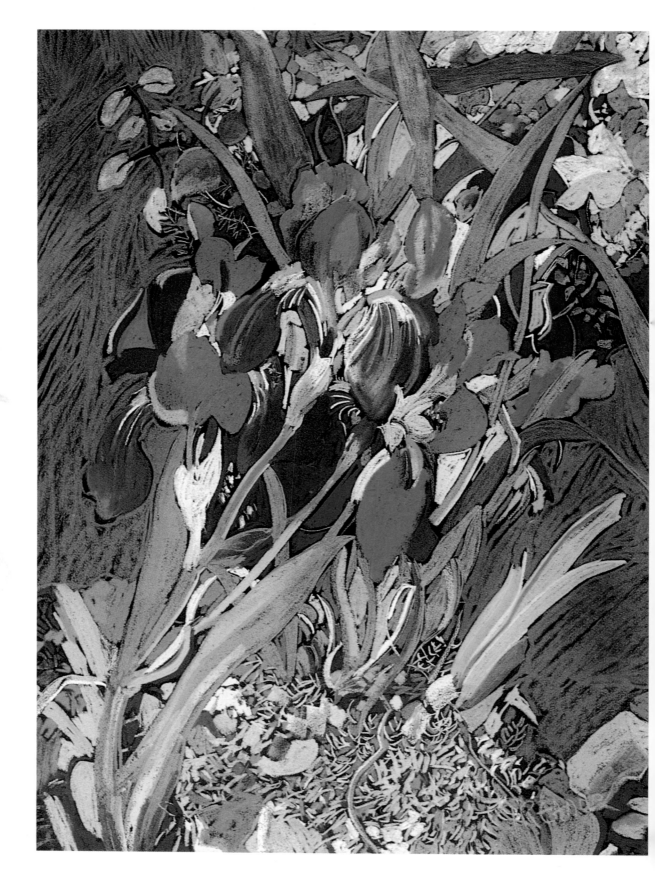

LEFT **'Lilac Iris with Rambling Roses'** 35x25in (89x63.5cm). Soft pastel. (*Private collection*) *The iris flower is a beautiful source of inspiration for all purple hues.*

with an alien one. The unexpected colour combinations which resulted from such an approach were fantastic. I had always been far too impatient to mix my pigments, therefore pastel with its ready-mixed hues helped me to respond immediately to any perceived colour.

I consciously search for colour in its natural setting where possible, but living in a temperate climate I find that colour tones are rarely bright enough for my palette. Colour can be found, however, in such unlikely places as the local supermarket, or a seaside promenade where an overwhelming richness of colour, texture and pattern, sometimes bordering on the kitsch, is to be seen.

I must admit that I have become extremely fond of the meticulously laid out flower beds in my local park. Rows of uniform, rigid tulips planted in circular beds are breathtaking in the twilight, when the last rays of the sun linger on their petals, transforming their hues into a glorious kinetic blaze of primary red and yellow (see, for example, the painting on pages 20–21). Busy Lizzies (*Impatiens*) with their rich, vibrant purples, reds and deep viridian leaves and a glowing vermilion head of a single geranium, will bring any dull, shaded patch in a garden to life.

In my front garden every year during the first few days of spring, a clump of flag irises somehow manage to appear in spite of a lack of attention. A day or so later their heads shrivel up in the spring showers, and I am left with only the stalks and leaves. It is not always feasible to paint at this time of the year because of the rain, and I feel rather conspicuous working so near a public highway, but whenever I do paint these particular flowers I am never disappointed.

Irises are a wonderful source of inspiration for artists wishing to explore the colour of purple. In theory purple is made from a mixture of red and blue. In practice it is difficult to make without the right pigments, as most mixtures turn to brown. It was the magical seventh colour on Sir Isaac Newton's colour wheel, and the symbolic colour of pride, or hubris, in the ancient world

of the Greeks. Rembrandt-Talens and Daler-Rowney offer a superb selection of purple tints in their pastel range. By adding touches of yellow and orange to these purples it is possible to create very striking compositions.

USING COLOUR: A PERSONAL APPROACH

Over the years you may have used colour in your paintings without really paying too much attention to selection or the process of its manufacture. Your choice of colour was probably intuitive when you were small and you were delighted with your efforts. But the influence of teachers and peer groups is powerful and the decisions you later made about colour may have become rather repetitive with a predictable use of safe colours: those you know look nice together in your paintings, and bear a resemblance to the tones in your subject matter, but with which, deep down inside, you are a little bored.

I would like to encourage you, from now on, to think about applying colour to your work in the same manner as you would draw an unfamiliar object: first reducing it to its basic component before applying tone, shadow and pattern. A single, coloured object should be easy enough to paint in pastel, for you only have to decide on one pastel tint. But if several colours or textures overlap on a surface, then you will have to identify and isolate the most dominant hues. Ask yourself 'What colours can I see? How many are there? Which family of primary colour – red, blue or yellow – do they belong to?' Once you have established these principles use your colour wheel as a guide to check the strength, or intensity, of the colours, and then choose pastels that come nearest to them. If there is a balance in a colour between either side of the spectrum, for instance turquoise may seem to be equally blue and green, then you will have to make up your own mind into which category it fits. I have solved this problem, to some extent, by storing my pastels in plastic or wooden cutlery trays which have built-in dividing rows. Each tray is home to a particular group of pastel shades. But this arrangement is flexible as more pastels are

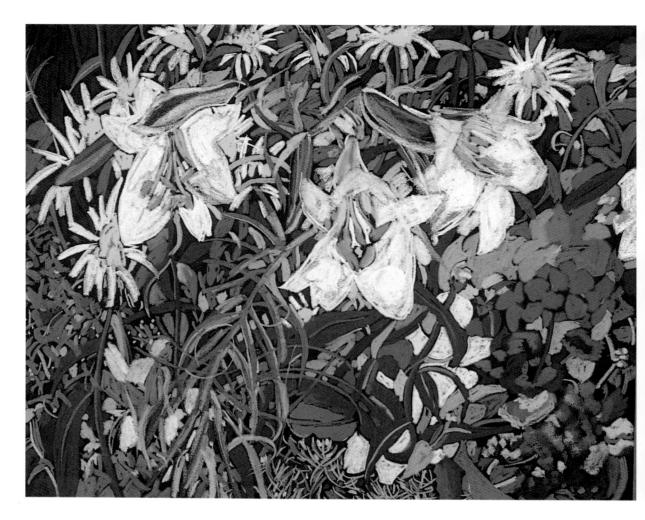

added to the trays. It is worthwhile remembering to put back all your pastels into their special compartments after you have finished with them, especially as a personal collection can amount to several hundred tints.

Remember, natural and artificial lights play tricks on the eye. Artists such as John Constable and the Pre-Raphaelites were very exact in their colour interpretations. Constable, in an effort to match his colour tones to those of nature, would conscientiously return to the same spot where he was working, at the same time of day, in all weathers.

You will probably realize at this point, especially if you own a beginner's set of pastels, that the range does not actually have the tint you require. Therefore you now have to make some important decisions. You could wait until you can find, or purchase, the appropriate pastel, but this is risky. It once took me three weeks to buy

a matching pastel because my art supplier had run out of stock. You could try mixing tints, but again this is time consuming, for it is difficult to blend pigment to an exact degree, and sometimes the same shade of pastel varies when taken from a different batch, though fortunately this is a rare occurrence with leading art materials manufacturers who have good quality control. You could improvise. My first introduction to pastel painting was founded on such a dilemma when I joined an adult education art centre, several years after I had finished art school. Art supplies were not provided, except for paper and charcoal. I therefore scrounged a few broken chalks from

the floor and did my best to match them to the still life set-up for the class. I turned out a picture where the model had a green face with bright orange hair!

I now have a massive pastel collection, numbering well over a thousand. But when I work away from the studio, I never take more than a dozen or so chalks with me. If I run out of pastel when working out of doors, I will use anything to hand as a substitute. From my cosmetic bag, lipsticks, eyeshadows and face powders have all been used at one time or another, as well as crushed flower heads and dry earth mixed with a little moisture from sun lotion. It is most challenging when one is compelled to seek out alternative methods of working.

As a colourist, pastel appeals very much to me. I find the immediacy of its application highly creative. The pigment is so pure and will not change in colour hue, unless fixative is added, unlike water and oil-colour which dry to a different tone. What you put down on your paper will be the final result. Changes occur only when the pastel is applied to different surfaces. It is a matter of trial and error before you discover the right paper, whether it is tinted or plain.

In my experience, I have found that at least one pastel colour has to be sacrificed when I choose to work on a very dark-toned paper.

Rubbing a single coloured pastel along the entire length of a sample swatch – which you may be able to pick up at your local art shop or obtain from a paper manufacturer – will give you some idea, in advance, of how that particular colour appears to change in its intensity. Swatches with varied textured surfaces will also influence colour sensation, as the minute pastel pigments adhere to the grain or tooth of the paper, allowing rays of light to fall intermittently.

Different types and brands of oil or soft pastel may be used together, but soft powdered chalks can fall across the path of oil pastel while you are working and subsequently adhere to its sticky surface. Previous layers of soft pigment may have darkened in colour tone due to the build up of chalk dust, streaking or fixative. These faults can be exploited to your advantage, if you are feeling highly creative and energetic. Or remedied, by applying better quality, though more expensive, pastels to the dulled sections, as a finishing touch. I, personally, would never advise using an eraser or blade when you are at the final stage of your work, should a mistake occur. Sennelier l'Ecu or Unison make glorious, pure pigment, pastels in giant or half sizes. Their strong colour and creamy consistency is powerful enough to override weaker tones and pigments, thereby restoring a lost colour that had sunk in the paper.

RIGHT **'Orange and Yellow Chrysanthemums'** 22x30in (56x76cm). Soft pastel.
A purple background makes the perfect base for yellow-orange flower petals because these colours lie opposite each other in the colour wheel and therefore are intensified.

THE COLOUR SPECTRUM

The colours we see fleetingly in a rainbow can be conjured up artificially by passing light through glass. To describe the process in more scientific terms: white light refracted through a prism will produce a band of brilliant colour known as the spectrum.

In the seventeenth century, Sir Isaac Newton experimented with a triangular prism and recreated a continuous band of colour, known commonly as the colour wheel, ranging from red through orange, yellow, green, blue, to violet. He may have failed to distinguish purple from his blue, because the colour of violet has the shortest wavelength in the spectrum and the human eye cannot see beyond it. However, he probably thought it prudent to add a seventh hue, for the number had been thought magical since the Middle Ages. Therefore, between blue and violet he named a rich dark blue, which he called indigo.

In theory, red and blue pigment mixed together make purple but in practice they usually make a brown, although I have succeeded using a spectrum red plus ultramarine. Sennelier l'Ecu red No 266 mixed with blue No 620; or Sennelier l'Ecu red No 681 mixed with blue No 353 will give you purples. I prefer to buy them ready made.

I use all the purples I can find in my pastel boxes when I am painting flower studies of flag irises or pansies (*Viola wittrockiana*); even so I never seem to have enough tints. By carefully overlaying mixtures of soft powdered lilacs from the exquisite Daler-Rowney range and rich, purple oil pastel, offset with highlights of orange and yellow, I have created breathtaking complementary hues.

You will have no trouble in finding plenty of green for foliage in the larger manufactured boxes of pastel, although, if you prefer to mix your own, then simply add yellow to blue. A particular favourite of mine is grey-green Conté crayon. It is a hard, thin stick which is very controllable, allowing for fine line definition around the veins and contours of leaves. The inner leaf spaces can be filled later with the flat edge of olive green Conté or softer pastel.

The first colours I search for when looking at a new range of pastels are orange and red, for these are the most vibrant hues in the colour wheel and the most useful for flower painting. Yellow mixed with red will make an orange, but it really is worth treating yourself to a giant Unison or Sennelier pastel if you are aiming for bright, striking, primary colour. They are a delight to use. I keep them for special occasions, carefully wrapped in tissue, like a favourite piece of jewellery. A dash of red vermilion strategically positioned can virtually lift a composition out of the shadows into the light. Try this technique with Busy Lizzie (*Impatiens*) against a dark background of viridian green. The bright red and shocking-pink hues of the flower's tiny, delicate petals will positively glow in contrast.

Complementary colours are often found in nature, for it is her way of ensuring cross-pollination by insects. The greatest of these contrasts is red against green, and the proportions and relationships of these opposite colours play a part in their brightness or 'contrast of extension' as it is known in colour theory. Some colours appear more forceful to the eye than others, so that only a small amount is necessary in order to create a harmonious balance. For example, in Claude Monet's 'Field of Poppies' or Van Gogh's 'The Red Vineyard', touches of red flowers sing out against the larger areas of mixed green fields.

There is a great deal more that I could say about the theory of colour but in this book I want to limit the subject to those aspects that have had a direct bearing on the development of my own paintings. I personally work within a very strong field of primary colour and fail to conform to a school of thought which advocates the use of so-called pastel shades. Unfortunately the phrase has become synonymous with the actual word. And subsequently a pastel painting is singled out as a picture that confines itself to tasteful subjects depicted in soft delicate, light shades. It comes as a surprise to discover that there are over six hundred ready-made pastel tints available today. As demand grows for their use, hopefully more suppliers will stock them.

It is sometimes difficult to absorb and remember all the technical jargon associated with the theory of colour, but it really doesn't matter as long as you develop, through trial and error, your own intuitive response.

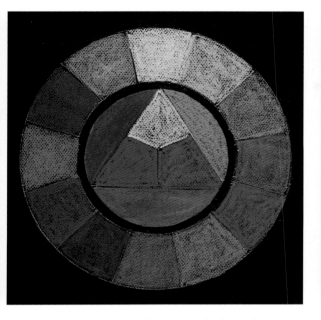

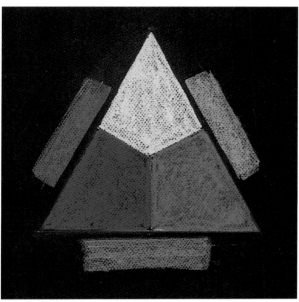

ABOVE The colour wheel. The outer circle shows the primary and secondary colours, together with the tertiary colours (made by mixing a primary such as red with its adjacent secondary colour, such as orange, to make a red-orange).

ABOVE The inner triangle of the colour wheel shows the three primaries: yellow, red and blue. Colours on the outer edge are secondary colours – orange, purple, green, made from a mixture of primary colour.

BELOW The colours of the rainbow.

ABOVE *The three primary colours with their complementary colours viewed on black. Note that they lie opposite each other on the colour wheel.*

ABOVE *The three primary colours with their complementaries viewed on a neutral grey surround.*

BELOW *Primary, secondary and tertiary colours.*

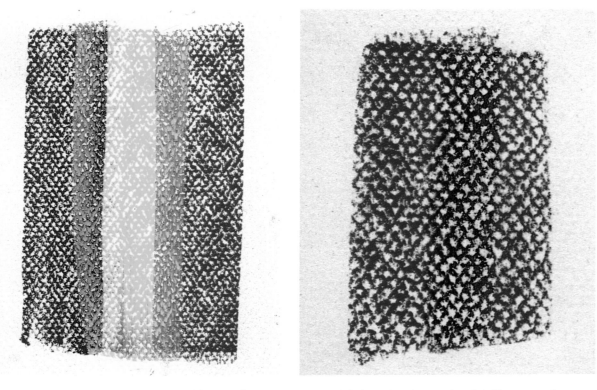

ABOVE *Mixing primary colours in pastel: blue + yellow = green; yellow + red = orange.*

ABOVE *Mixing colour in pastel: red + blue = purple.*

LEFT *Colour mixtures can be made in pastel by the scumbling technique: one colour is dragged very lightly over another without total obliteration.*

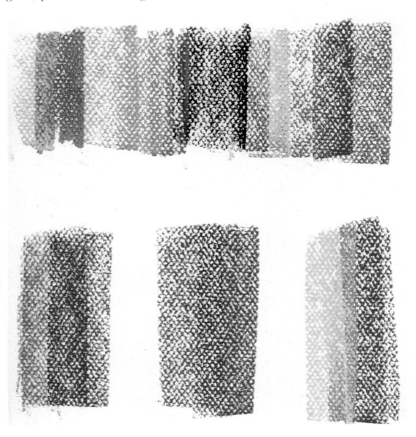

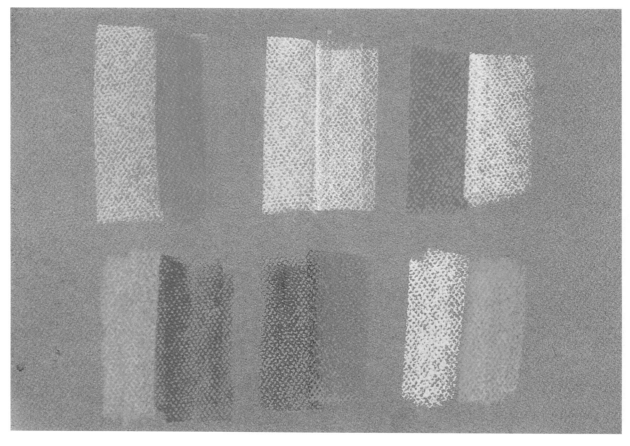

ABOVE *Every colour has a complementary colour.* BELOW *Subtle harmony of complementary colour.*

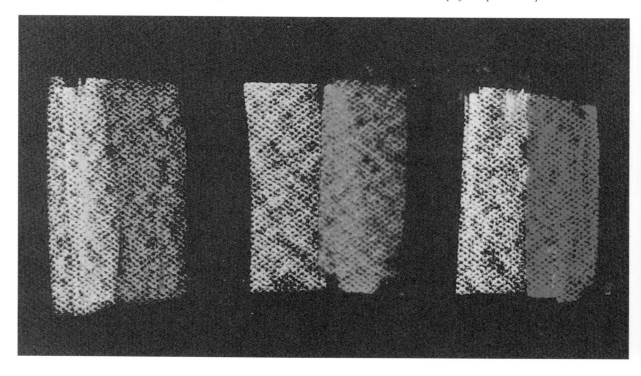

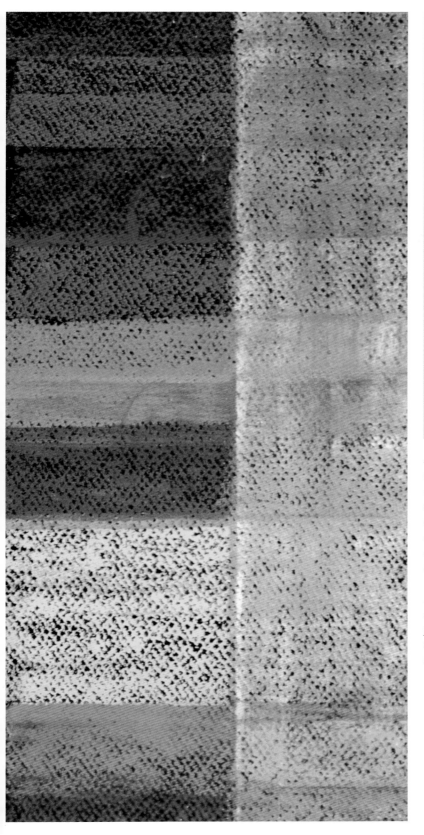

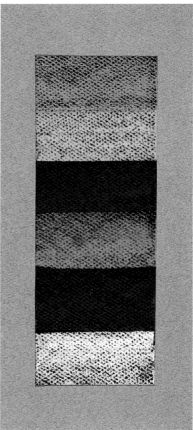

ABOVE Tertiary pastel tints viewed on a warm tertiary background of grey Ingres paper – the grey area will appear tinged with the complementary hues. Dull colours and grey can be livened up in this way by contrasting them with a saturated hue of the same tone.

LEFT Contrast of saturation is the degree of purity of a colour: for example, when a colour is diluted with white it weakens the intensity and makes it appear colder.

Chapter 6
LOOKING FOR FLOWERS TO DRAW AND PAINT

DRAWING AND PAINTING OUTDOORS

Throughout my home, part of which is a studio, I have tried to create an environment that is both visually and mentally conducive to my needs as an artist. I would love to own a conservatory where plants and flowers could grow all year round, but as an alternative I have placed huge, lightweight, plastic pots filled with exotic palms: Swiss-cheese plants, orchids, succulents and cacti in an upstairs bathroom where watering facilities and natural sunlight are excellent and where, leading off this room, is a delightful south-facing roof-garden.

Unfortunately most of the afternoon sunlight on this sundeck has been lost over the years due to the overhanging branches of a neighbouring ash tree and it was here I had habitually painted the summer flowers of potted plants in sunshine. Luckily I live in close proximity to one of London's most prestigious and well-kept Royal parks and hidden away from public gaze are a few quiet, secluded areas, where wonderful shrubs and flowers are lovingly cultivated in a manner far superior to anything I have ever attempted. Each season I take a hard look at the park gardeners' methods, hoping to borrow some ideas for my own small garden, while my observations are also taking into account suitable drawing and painting locations.

Many elegant eighteenth century buildings and boundary walls back on to the park, and it is here one finds excellent azalea, rhododendron and later, rose bushes rich in hues of pink, yellow and violet. Near one of these fine enclosures I first set up my easel to paint but was disturbed by the slight chill river-wind that found its way into the park through the wrought iron gate set in the ancient garden wall. Now, my favoured haunt is a more sheltered and secluded spot in the park where dogs and ball games are forbid-

LEFT **'Lilium Regale'** 32x44in (81x112cm). Oil pastel and chalk.
In my back garden a magnificent cluster of lilies faithfully reappears every season out of an old wooden beer barrel.

RIGHT **'Blue Flowered Delphiniums'** 30x21½in (76x54.5cm). Soft pastel.
Rather a lot of things are happening in this complex arrangement of border plants. I therefore decided to include one strong blue colour that would create a focal point.

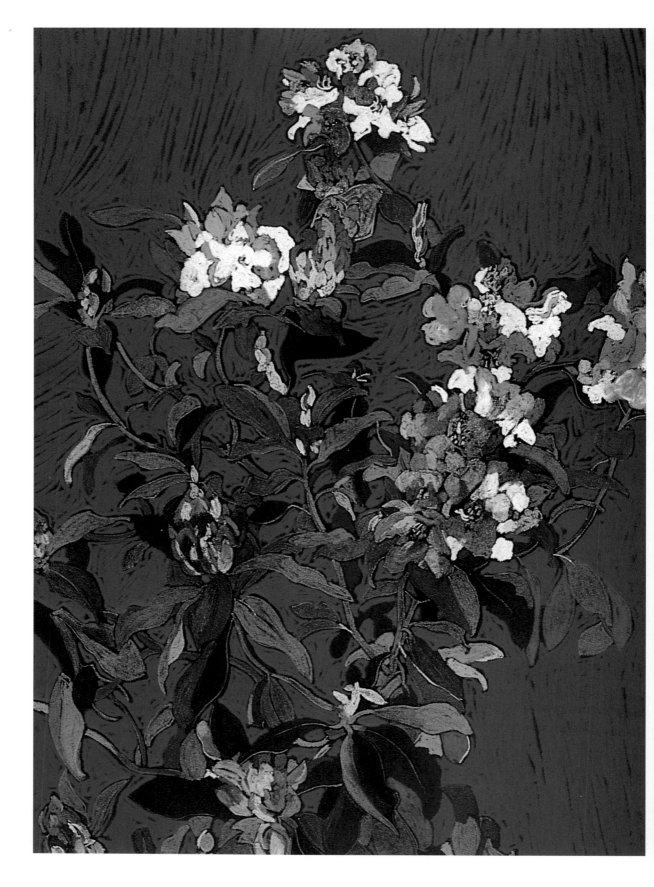

den and where on weekdays it is practically deserted. Here giant, circular flower beds filled with rather ostentatious, regimented rows of ever-changing bulb flowers are on display and in spring the tulips are breathtaking. At the height of spring and summer the mixed beds of border plants remind me of a delightful cottage garden, and three of my most successful and happy paintings, 'Lupins and Daisies', 'Spring Flowers' and 'Summer Glory' were painted here.

LEFT **'Rhododendron'** 38x26in (96.5x66cm).
Soft pastel.
A bush growing in a quiet corner of Greenwich Park.

BELOW **'Greenwich view from studio window'**
The colour of garden trees and foliage change dramatically throughout the seasons; especially in autumn when turbulent skies rapidly change from grey to indigo.

It is not uncommon for children who picnic and play in the park to gather round as I work and their inquisitiveness presents an opportunity for me, as an art teacher, to show off the delights of flower painting in the pastel medium to an appreciative audience – something that does not always happen in a school classroom! The groundsmen who tend the plants are somewhat reticent about engaging in conversation with the public but on these occasions they too have given helpful advice about plant care, as well as confirming correct botanical names.

AUTUMN SKETCHING

In mid autumn it is possible, if the weather holds, to capture in a drawing or a painting some of the magnificent complementary colours which appear then. The leaves of autumn trees,

Rough sketch in Greenwich Park

particularly horse-chestnut, positively sing out in vibrant hues.

A colour can appear to change when placed next to another: the three primaries – red, blue and yellow – provide the most intense examples of such contrasts. Leaves which have traces of red and yellow will sparkle against a sky backdrop of bright blue, ochre, deep grey or white; the trunks of lime trees turn charcoal-black as summer ends to heighten further this vibrancy of colour. Light also plays a major role in painting and colour interpretation, but as tonal values change throughout the day, it is better to make any judgement about colour when the sun is shining.

When I painted 'Greenwich Park in the Autumn' the last few days of that autumn had been exceptionally cold and wet, and this beneficial effect on foliage and grass, which normally would have withered quite quickly after a long warm summer, made my local park in Greenwich look most inviting. I also realized that the sudden cold spell might make the tree leaves, which are so beautiful at this time of the year, prematurely drop from the tree and rot on the ground.

I had taken the precaution of pre-packing a stand-by sketching suitcase should a break in the weather occur. Late one afternoon the rain had stopped, but as the ground was muddy and the atmosphere dank, I decided to off-load my large drawing board and A2 cartridge sketch pad and instead, quickly tore up a superior quality sheet of Canson Mi-Teintes into smaller pieces, which I secured on to an A4 board with a thick wad of newspaper folded underneath. The whole package was held fast with a large dog-clip and put into a plastic shopping bag, which later on doubled up as a ground sheet.

For colour, I took along a complete set of Sennelier extra soft l'Ecu pastels plus a limited range of Conté crayons, not forgetting, of course, fixative and a tea flask! It isn't wise to take sandwiches as pastel dust gets into them (I keep hands clean with moist baby-wipe tissues). Although the day had been very calm and still in spite of the rain, I wore a thick sweater and lined walking boots, as damp can penetrate without

you realizing, especially if you become totally absorbed while working in the same spot.

I found that there was more time for drawing because I had made an effort well in advance to select suitable locations and subjects. However, much to my annoyance, I rapidly used up all my paper. I really thought that I had prepared properly, but I knew better the next time!

It is not always necessary to fix pastel *in situ*, but I like to, in case of sudden wind-gusts or accidental damage on the way home. It is also safer to use fixative in a well-ventilated area.

One problem, which I had not foreseen, was the buckling of a sheet of porous pastel paper. It had obviously lain too long, unprotected in my trolley, after I had finished my first sketch. Mounted pastel board counteracts this effect, but is not always a practical alternative, because it is expensive if used just for sketching purposes. I made a mental note to carry, in the future, a thin, light sheet of cardboard, large enough to accommodate my size of sketch sheet. As it turned out, it was not necessary to fix or protect with a waterproof bag every single sheet, as I found that the newspaper, which I had packed in order to make a softer base for my work, also made an excellent portfolio substitute. It was

easy to place a single sketch in between separate pages of newspaper. Used paper is more vulnerable on the return journey home, even if it has been meticulously packed. It is so disappointing to find a pastel composition blurred by residual pigment which has rubbed off from another piece of work or from static build-up, caused by friction in plastic sheets.

PROJECT:
PAINTING AN AUTUMN SKETCH

Make the most of the beauty and colour of autumn by sketching outdoors as much as possible. Carry only a few pastels with you – I suggest you restrict your palette to:
- black
- white
- grey
- brown
- yellow ochre
- indigo blue

Avoid using a spectrum blue for the sky as it will contrast sharply with orange and will take away that special autumnal look in your painting. Try using white or grey-blue as sky background instead.

'Greenwich Park in Autumn with Seated Figures' 11x14½in (28x37.5cm). Pastel.

LEFT **'Dying Tulips'** 41½x30in (105.5x76cm). Soft pastel.

These flowers are at their peak in terms of colour and have an added sense of drama just moments before the petals fall.

OVER PAGE **'Summer Flowers'** with border 31x37in (79x94cm). Soft pastel.

BELOW An assortment from sketch books, left to right:
'Waiter with Kentia Palm, La Coupole, Paris' Oil pastel on A4 ivory board pad.
'La Spezia, Palm Tree on Tuscany Coast' Oil pastel on A6 sketch pad.
'Hospital Gardens at Arles' Black felt tip on A6 sketch pad.
Pastel applied over watercolour on A6 sketch pad.
'Flower and Jug' Pen and ink sketch on A6 pad.
'River in the Dordogne' A5 sketch pad.
'Roof Top Villa' Oil pastel on A6 sketch pad.
'Garde du Menton with Palm, Côte d'Azur' A6 sketch pad.
'A Bit of Tipperary – A House in Albany, New York' A6 sketch pad.
'Cypress Tree in Malcesine' Oil pastel and watercolour on A6 sketch pad.
'Wrought Iron Table and Chair in a Garden' A6 sketch pad.

SKETCH BOOKS

However well-intentioned I am on a sketching holiday, I invariably end up filling the very smallest of my sketch pads with the drawings I fully intended to do on my pre-packed sheets of large pastel paper. Although it is possible to continue working on a sketch on my return, it is more difficult to preserve its spontaneity and authenticity because there is a tendency to overwork them and, for this reason, I don't really like doing it.

My A6 pocket-size sketch pads make it very easy for me to draw without being noticed and therefore I carry them in my bag or pocket whenever possible. There have been times when I have felt a little uncomfortable, almost voyeuristic, as I spy on people in various modes of undress on a sunny beach, but I revel in the patterns and colours of exotic beachwear. However, when the sun goes down I am more than content to sit in a café, surreptitiously making drawings of the waiters as they dash between the tables. If they are a little slow to take my order I simply pass the time away by making quick sketches on my lap as I sip an aperitif: it

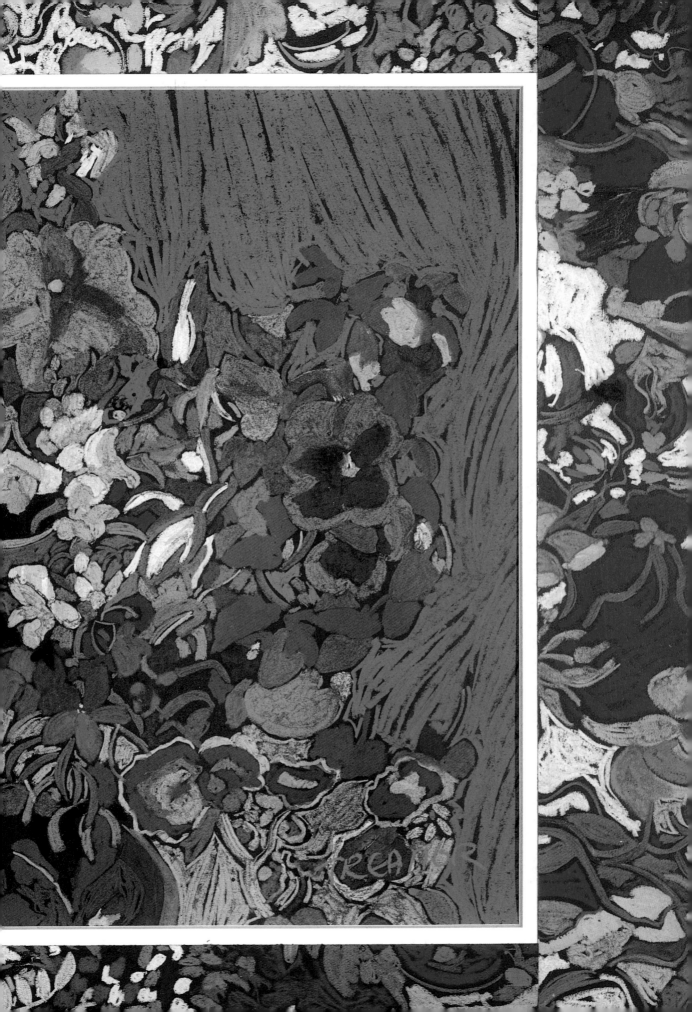

RIGHT **'Midnight Tulips'** 30x36in (76x91.5cm). Soft pastel, oil pastel and chalk.
This painting is full of energy and luminosity for tulips have wonderful sensual shapes which are wholly unpredictable in movement.

would be unfair to place my pastels or pad on to a crisp white tablecloth. Therefore, I code colour hues with a letter of the alphabet or add other snippets of relevant information with the odd word or two. I then add pastel colour at a later time in my hotel room.

I once received a commission, which involved painting an enormous stage backdrop for a theatre company. The only practical way to transfer my pastel-painted jungle scene of flowers and animals on to the gauze screen was to make smaller replica sketches based on the original. I divided these up into a number of sections, by drawing vertical and horizontal lines to make a grid. The actual number of grid lines or size was not important as long as there was enough for reference. I then gave each stage-hand a photocopy so that they could climb up ladders and re-draw by hand my original design on a much larger scale, using very soft charcoal which could be gently blown away once we were satisfied with the arrangement. It is possible to obliterate grid lines on paper with oil pastel, but soft, light toned pastel can pick up traces of charcoal and cause smudging.

DRAWING AND PAINTING

I firmly believe art work should be rhythmical and unsentimental yet decorative and therapeutic, and the study and painting of the flower fulfils all these aspects. I have learnt to wait until the atmosphere is calm before working and several days, even weeks, can go by before I actually begin a flower painting, but I do not feel that this time is wasted. I question my motives to ensure I do not feel obliged to paint out of guilt at seeming lazy. Every so often I see something that attracts my eye and then it is a question of finding the right time and space to shut myself off quietly and paint.

My portable easels are always to hand and my pastels permanently on display. Once I start a composition I feel compelled to finish it at one sitting; this is not always wise, so I try not to rush it in the first few hours. The challenge and difficulty of working in pastel is the realization that there is little room for error of judgement – it is essential to have a good eye and excellent draughtsmanship; all other mediums offer compromise but the beauty of pastel lies precisely in acknowledging the exact moment when a painting is perfectly complete before it then becomes merely overworked.

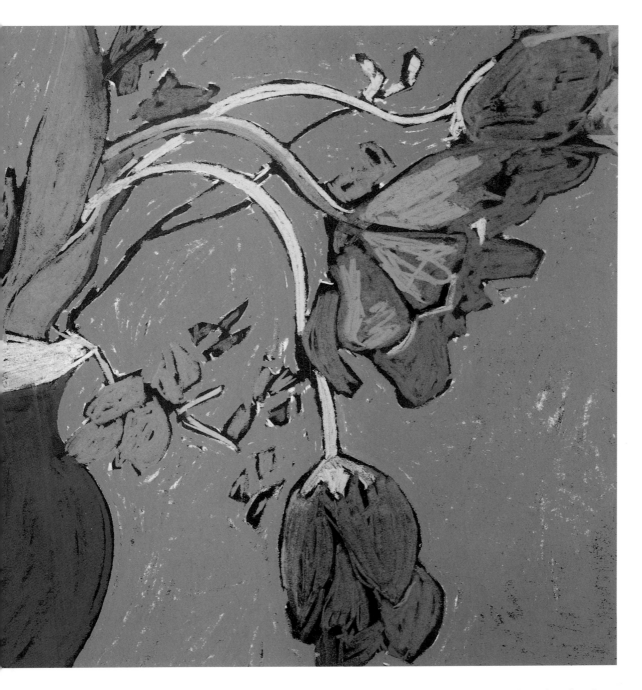

PREPARATION
. .

When I have found some flowers to paint I begin to feel anxious that something may destroy them, be it insect, bad weather or decay. Cut flowers always bring on these fears because I buy them cheaply when they are at their peak, for this is when the colours and shades are the most vibrant and dramatic. I know then I must work very quickly without interruption; it is this sense

of urgency that always sets the adrenalin flowing.

Cut flowers will keep fresh for longer if the water is kept clear with a drop of vinegar and any leaves under water are removed from the stem. The rigidity of tulip and lily stems can be maintained by pricking the stalk with a needle just where it meets the flower head so the stalk will draw up water by capillary action.

In my painting entitled 'Midnight Tulips' I allowed the flowers to arrange themselves: tulips

are particularly adept at this, losing their uniformity and stiffness when in water, providing wonderful, sensual shapes which are wholly unpredictable in movement. This painting is also very special to me because I worked so hard at it. At first the background was painted in white Conté chalk and although I was well pleased with the shape and pattern of the tulip heads, the final application of white to the background had completely killed off the vibrancy of the red in the tulips' petals. I was furious as I went to bed that night. Part of me wanted to tear up the painting and start afresh but this would have been a terrible admission of failure and it would take me a long time to recover from the frustration and defeat of such an act of vandalism. Also, my initial response to the flowers would be lost.

As the hours went by, I grew more and more upset until I finally descended the stairs in my dressing gown, determined to solve the problem one way or the other, knowing that I would find it impossible to work on more than one painting at a time. The gods must have been with me for I took one look at the ruined picture and knew intuitively what to do. Using a vivid blue oil pastel with frenzied strokes, I managed to erase the fixed undercoat of white chalk, allowing only minute traces to show through. The same method was then applied in reverse, using red chalk over purple oil pastel, to the petals of the tulips – the real ones by now drooping so badly they touched the table, about to fall off at any second. With my anger vented I left the composition and retired again for the night.

Next morning I could hardly believe my eyes. What had appeared to be a badly damaged composition, fit only for the dustbin, was now transformed into a painting full of energy and luminosity. I could barely recognize it as my own work. I had unwittingly developed a technique that I have never been able to repeat successfully since!

RIGHT '**Spring Symphony**' 23x30in (58.5x 76cm). Soft pastel.
A few years ago I received a beautiful bouquet of flowers which inspired many of my favourite flower paintings.

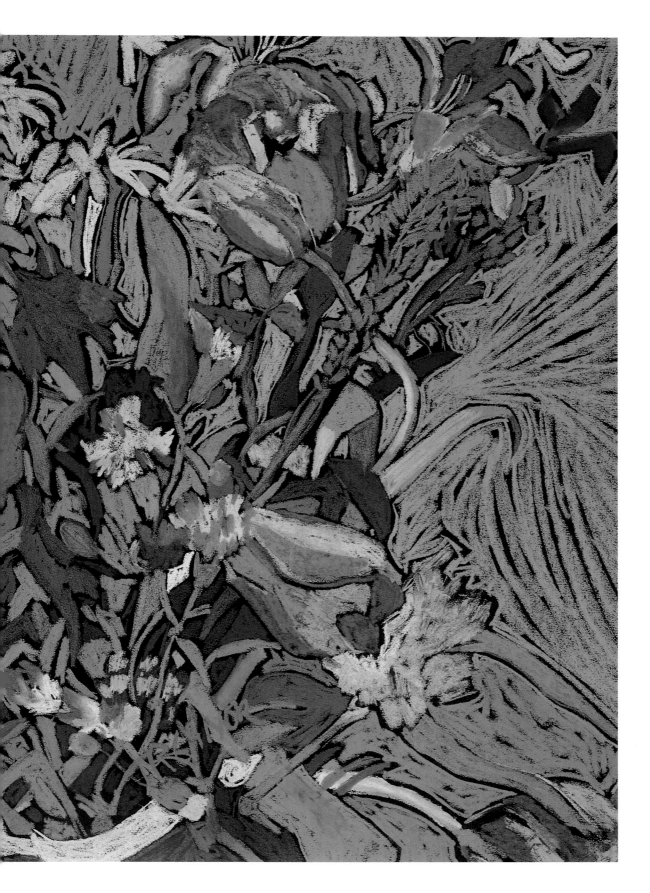

Chapter 7
PERSPECTIVE AND COMPOSITION

SIMPLE PERSPECTIVE

It is important to remember that the laws of perspective are not absolute truths in themselves, only the means by which certain societies have interpreted a visual illusion of space. One of the most popular rules of drawing developed during the Renaissance and still taught in art schools today is linear perspective which gives an effect of solidity, size and relative position between visible objects. To obtain the maximum benefit from this theory, it is necessary to draw with one eye closed whilst focusing the other on a fixed point to which one refers at all times. There are three basic elements in this form of perspective:

• the horizon line which is a straight line drawn horizontally from one point to another, level with the eye of the onlooker.
• the view point which is determined by the position in which the onlooker directs their gaze.
• the vanishing point which is found on the same line as the horizon and is the place at which parallel lines, surfaces or planes, appear to converge or meet as they recede into the distance.

A DIFFERENT APPROACH TO PERSPECTIVE DRAWING

There are other rules of perspective that are equally valid which can be applied to an artist's work but learning such theory can radically alter

LEFT **'Summer Glory'** 29½x21½in (75x54.5cm). Soft pastel.

BELOW **'The Quays, Clonmel'** 23x16½in (58.5x42cm). Oil pastel.

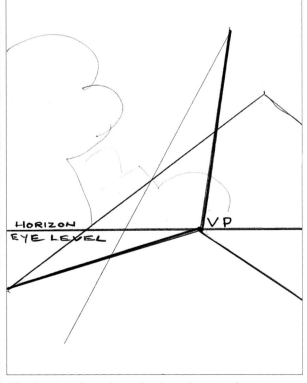

The drawing above shows the three elements of perspective.

In the line drawings above, both positive and negative shapes can be seen to have equal value.

LEFT **'Rubber Plant'** 22x30½in (56x77.5cm). Oil pastel.

the unique perception that each individual has on the world. Many trained artists have spent a lifetime trying to undo such doctrines.

In my own drawing and painting, I have moved away from traditional perspective to a more unconventional private interpretation that allows for multiple approaches. These represent distorted space, rather than creating a correct spatial illusion; shapes which symbolize emotion as well as content; and colour in its purest tones, devoid of deceptive shadow.

I would not care to exclude perspective theory from my work altogether, because it is useful knowledge should one want to pursue a career in teaching or commercial art where it is a necessity. I find it amusing when my strict perspective training creeps through into some of my more avant-garde work and I remember a phrase I heard somewhere – that an artist can hold two opposing views and yet still function.

SPACE & RELATIONSHIPS

If you wish to give your composition a greater sense of depth and perspective, then it is necessary to add some boundary lines that will position your objects in space. The way these lines relate with other shapes in the composition will have a profound effect on the overall balance and harmony of your picture. The illustration below demonstrates:

1 The base edge of your paper can act as a natural boundary line.

2 The inner shape inside a picture will appear to float in mid-air if there are no surrounding lines that link it to the outer frame of the paper.

3 Putting in a horizontal line will link the inner shape to the edges of the paper and will give a more representational look. Take care not to place it in the centre of your paper as this will divide your composition into two sections.

4 A diagonal line as opposed to a horizontal line will add more movement to the composition.

5 A vertical line will add depth and also acts as a perspective guide; it should correspond with the straight edge of your paper and go in the same direction, but take care not to position it in the centre of a horizontal line, otherwise your composition may become static.

6 It is possible to create a more abstract interpretation of the composition if blunt strokes of pastel, without any line definition, are applied in quick succession.

BELOW Space and relationships.

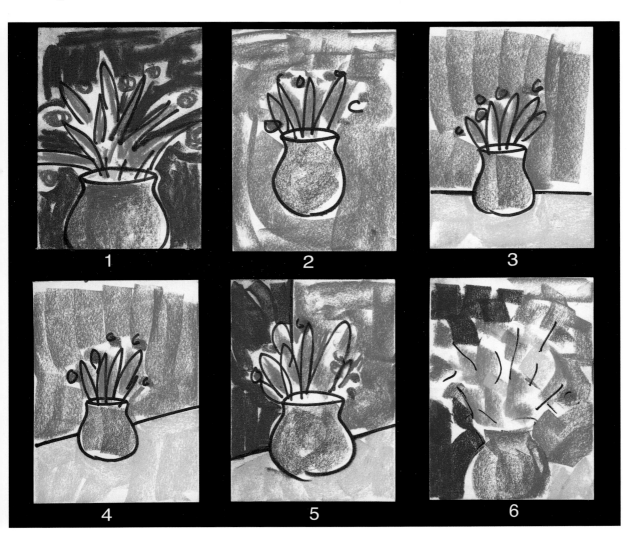

FLOWER COMPOSITION WITH STILL LIFE

Sitting in front of a blank piece of paper in the hope that some inspirational, creative force will suddenly enter into one's head is a sure way of driving out the imagination. There will, of course, always be exceptions to this rule, but it has been my experience, as an artist and a teacher, that creativity and visual awareness are activated more by exposure to stimulating thought and surroundings both past and present, than by solitude.

Sketch books have always been linked with the artistic thought-process in much the same way as a note-pad is to a writer, but I wonder if this association owes more to the romantic idea of the artist. For in all my years of teaching, I have observed only a handful of people actually working from sketch books. Usually, a sketch is just a miniature version of a composition because a larger piece of paper was not available or the size too daunting.

TOP, ABOVE AND RIGHT Rough sketches of a still-life flower composition.

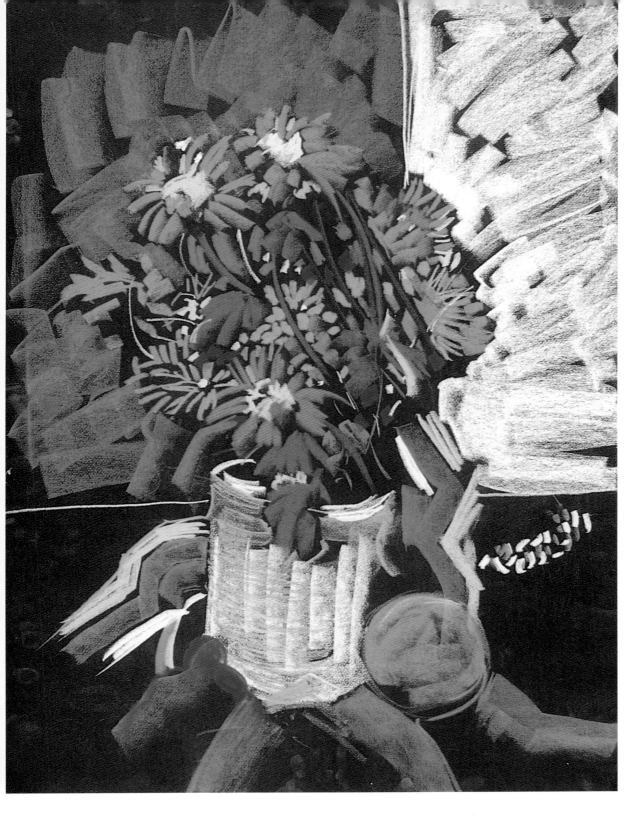

However, there is more than one way of compositional sketching. I rarely make preliminary drawings, preferring instead to throw myself directly into a composition in order to capture the maximum effect. This may appear, on the surface, that I leave too much to chance or accident but it must be appreciated that I spend days or even months of preparatory work in my head, and a great deal of time and effort is put into searching for suitable themes, locations and paraphernalia.

Inexperienced students frequently complain to their teachers that they are unable to make an exact replica of an object. What they're really saying is that in their mind they already have a finished picture of the subject matter they are now seeing.

At first sight the appearance of objects is often deceptive due to the preconditioned flash of recognition, but why not allow the flowers to dictate their special characteristics to you? The outcome will be much more fun. Other artists may choose to make preliminary sketches in order to familiarize themselves with their subject matter and if you are just starting to draw or paint for the first time I might advise this, but I do believe that this deadens spontaneity as will an over-zealous adherence to the laws of linear perspective.

Admittedly, I start off by consciously dividing my floral composition into two separate compartments, experiencing a 'background' behind my 'foreground' images, but I soon become oblivious to this once absorbed in the painting. You may have noticed that my flower jugs sometimes appear at an oblique angle. This is not a lack of traditional perspective drawing expertise: the distortion occurs naturally because I allow peripheral vision to play a major part in my observations and also I focus on multiple view points as well as searching for positive and negative shapes.

Working by these methods should alleviate any boredom that might occur in a repetitive or familiar object. We have become so accustomed to paintings of flowers, that the very mention of them sometimes evokes a stereotyped imitation.

SETTING UP A STILL LIFE

As well as the plants and flowers for my compositions I love collecting all the various bits and pieces which I either store in boxes or leave scattered about the house, but recreating their form in a still-life composition is, for me, the greatest joy of all. I am constantly on the look out wherever I go for subject matter for my theme ideas and it can take years to find absorbing, original objects from which to work. Once the objects are discovered, long periods of time are necessary for me to familiarize myself with them. Only then do they become part of my family.

Some plants live for years and, no matter how many times you draw them, they will always show you a different side of their nature, especially if arranged in different positions or

grouped with unusual objects. I suggest that you take time choosing which articles to arrange with your flowers when setting up a composition. Although I enjoy putting together objects that are out of context, I am not happy with arrangements that do not fit together or make some kind of sense. Careful colour co-ordination or texture can be the agents which unify the whole composition.

You will have a better understanding of the structure and form of your objects if you simplify their shapes. As you work through your composition, keep these geometric shapes in mind at all times. This is the moment when a small sketch on a rough piece of paper will be useful and it will also help to break the ice, for knowing exactly where to start your drawing or painting is a difficult decision to make and pastel paper is expensive and incorrect chalk marks are not easily erased.

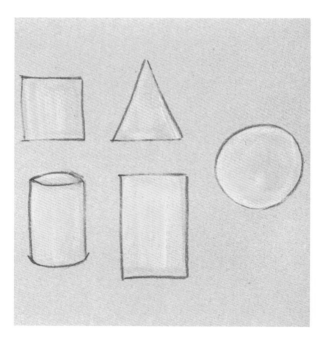

ABOVE Five basic geometric shapes.

RIGHT **'Phoebe's Favourite'** 37x25in (94x63.5cm). Pastel.
A slightly unconventional approach to a more traditional still-life composition.

OVER PAGE **'Tulips with Bird'** 25x38in (63.5x96.5cm). Soft pastel.
It is fun to include animals in a still life.

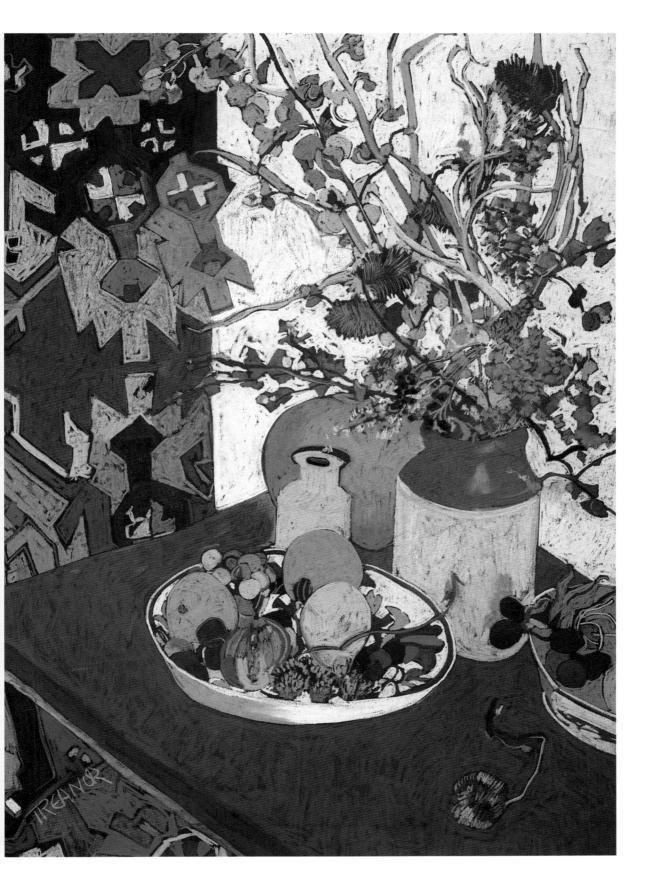

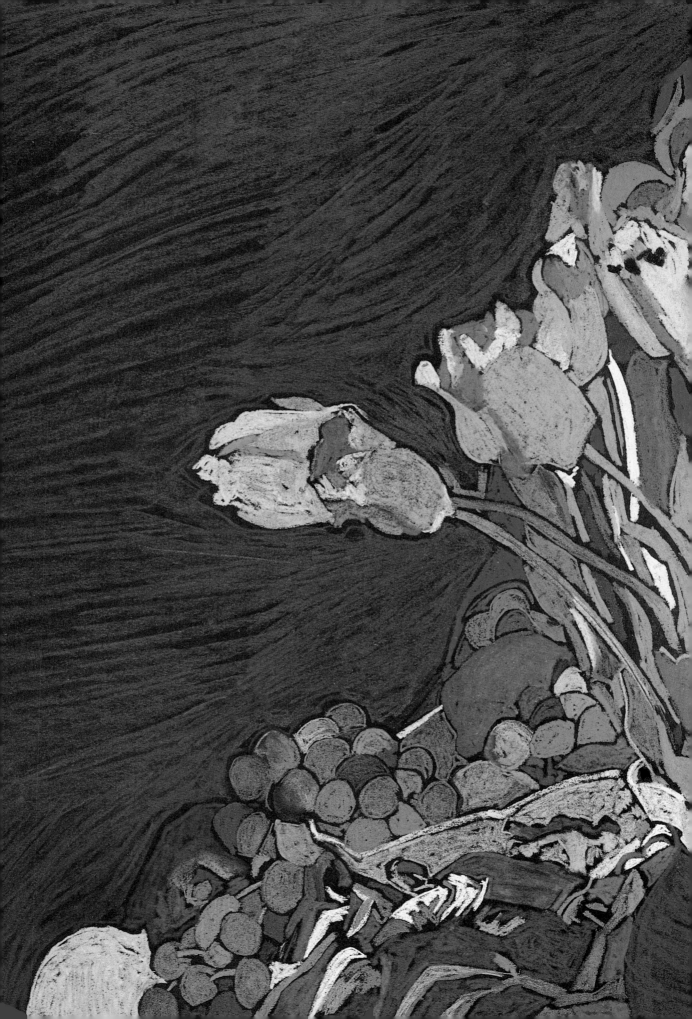

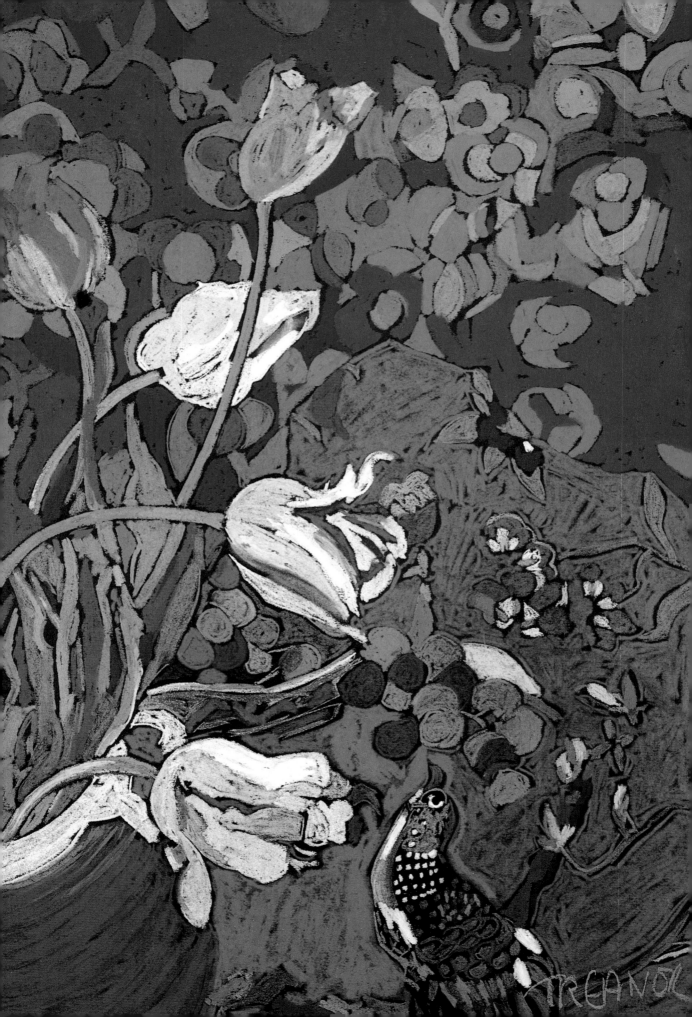

HOW TO BEGIN
. .

You should decide, before you pick your pastel pencil or chalk, whether or not to make the flower study vertical or horizontal (sometimes referred to as 'portrait' and 'landscape'). This decision is very important, so do take your time. A small cut-out viewfinder about 1x1½in (2.5x3.8cm) can be made easily from card to enable you to determine which way the composition should be viewed or you can use your cupped hands to make a similar window. If it is placed on the horizontal it is known as landscape, and portrait if it is on the vertical. It may

ABOVE **'Moonlight Fuchsia'** 25x38in (63.5x96.5cm). Soft pastel.
A horizontal, landscape, composition.

RIGHT **'Fuchsia'** 38x25in (96.5x63.5cm). Soft pastel.
A vertical, portrait, composition.

BELOW (LEFT) It helps to divide your paper into sections before drawing in your subject. (CENTRE AND RIGHT) Positioning a focal point off centre, whether in a landscape or portrait format, can add interest.

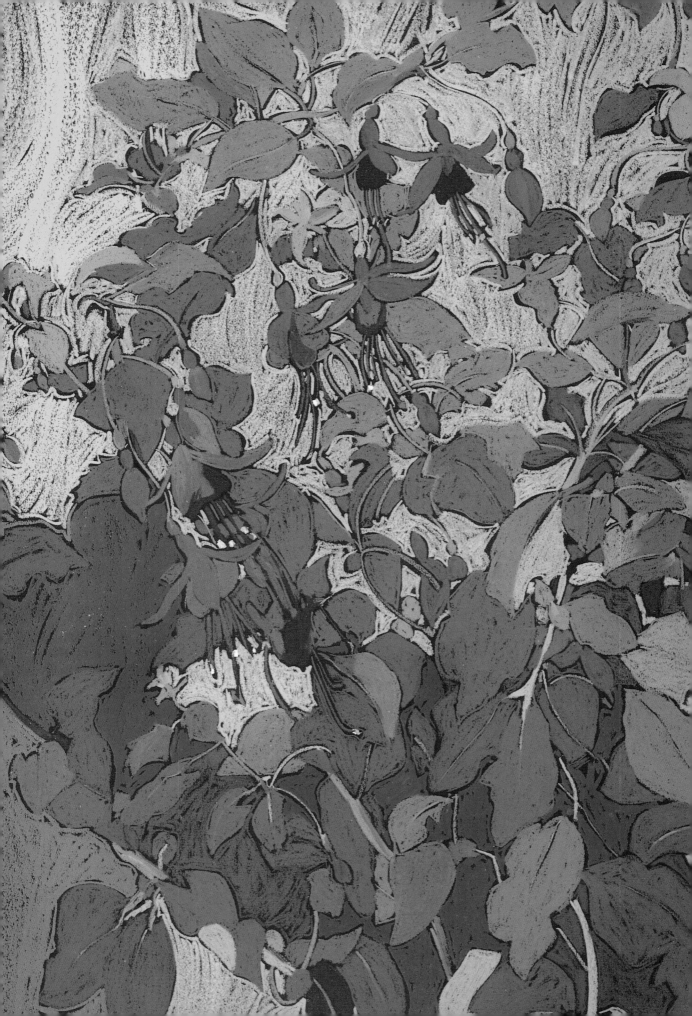

LEFT **'Fiery Tulips'** 29x40in (73.5x101.5cm). Oil
pastel and chalk.
*The principal focal point in the composition is on the cross
line, but two strong curved diagonal lines draw the eye away
from this awkward arrangement in the centre on to the outer
border.*

BELOW LEFT **'Spring Flowers'** 25x38in
(63.5x96.5cm). Soft pastel.
*The main areas of interest are centred in the white flowers
in the middle of this composition, but the angle of the han-
dle on the terracotta jug leads the eye in a diagonal direction
towards the flowers in the distance.*

RIGHT **'Pete's** *Aloe* **(Partridge Breast)'** 38x25in
(96.5x63.5cm). Oil pastel and chalk.
*The long spiky stem of this succulent plant forced me to use
the paper in an upright position.*

help to rule a vertical line with Conté chalk in
the centre of your paper and another horizontal
line across in the opposite direction so that you
can avoid creating focal points in the middle of
the paper. This cross will divide your paper into
sections and will guide your hand when drawing
directional lines and complicated shapes. A grid
with a greater network of parallel lines will give
a more analytical drawing. The outline of your
shapes can now be drawn in gentle Conté chalk
or pastel pencil.

I prefer to sit quietly in front of my blank
piece of paper which has been firmly secured
with tape and dog-clips on to an easel, glancing
in bouncing ping-pong ball fashion back and
forth from the flowers and paper. After a while,
rather like a small child playing with a jigsaw
puzzle, I am able to pick up on a particular point
in the flower composition and very slowly and
with great care painstakingly begin. This
moment is crucial, for if I choose to make my
initial mark in the wrong place or use an inap-
propriate colour, my painting will be unsuccess-
ful. The tension is now at its height: once I
break it I am overwhelmingly relieved. In this
ecstatic mood I immediately stop working and
make a cup of tea, because hopefully the rest will
be plain sailing.

If you create a point of interest or focal point
in your composition it will prevent the eye from
wandering aimlessly over your picture. Your
subject matter will be more visually stimulating

if it leads the eye in and around the painting and
not out of it. If you make a mistake by position-
ing a shape too near the edge of the paper, then
you must either remove it or disguise it by
drawing the eye's attention away from it with
another shape or colour that leads back into the
composition. Some artists have the instinctive
knack of arranging their shapes in a proportional
and aesthetically pleasing manner which creates
harmony. This perfect balance is known as the
golden section.

I can work in my first euphoric state for hours
or days depending on the size of the flower
arrangement, skilfully putting the jigsaw pieces

together. Having developed this sense of urgency in my work, it is vital that I know when to stop working. It is a selective process understanding precisely what to leave out in my painting. I have no preconceived ideas about the imagery set before me, only a vague feeling as to what the end result might be but the vaguer the better!

FLOWER COMPOSITION USING CUT FLOWERS

The container in which a bunch of flowers is placed plays a very important role in the overall design of your composition, even if later on you may decide to leave it out altogether because of lack of space or the fact that its shape aesthetically distracts from the design as a whole.

It is important to think about a suitable container at an early stage because you won't want to change it once you have started, for fear of disarranging the flowers or damaging petals. It is, therefore, worth spending a little time visually evaluating your composition before you start actually painting. When setting out my still life, I like to put in more props than I intend using, as this will give me a chance quickly to add further bits to my composition, should the need arise later on without having to search for them at a crucial moment. I also pay attention to the room in which I am working, that too will become an important influence on the outcome of my work; if it is too cold or uncomfortably furnished I will rush my painting and will fail to enjoy it.

Ikebana is the name given to the ancient art of Japanese flower arrangement. The first recorded dissertation in the twelfth century on this subject warned against arranging flowers in moods that were tense, antagonistic or melancholic, for such an arrangement reflects one's soul and it was considered highly ill-mannered to transfer a poor state of mind on to another person.

Taking part in some flower-pastel workshops, I have been amazed at the unimaginative selection of vases that have been brought along to class, ranging from plastic buckets to milk bottles! In theory an artist is expected to see beauty in all things, but I strongly believe that we are influenced by our surroundings on a much deeper level than is realized, and it is through these subtle absorptions that we re-create the shapes we have seen. The flower studies by Van Gogh painted in Arles and St Remy compared to his earlier work in Lille are living proof of this. To put it more simply; we are what we see and if we surround ourselves with drabness, then we risk becoming ugly in spirit.

FLOWER COMPOSITION USING VARIED CONTAINERS

In some mysterious way flowers, like the food we eat, seem to adopt the personality of the receptacle in which they are placed, and consequently unattractive patterning, crude texture or unsympathetic proportion can influence their aesthetic appeal and spoil our visual appetite. I seldom put flowers into glass vases when setting up a composition because of the distortion of the stems, although other artists find this an interesting challenge. A more mundane reason for not using glass vases is that well-designed cut crystal is very expensive and easily damaged or disfigured by rotting stalks or by the deposits left when hard water is allowed to dry up. The latter is a common fault of mine, I'm afraid, as I become engrossed over long periods with my painting.

TERRACOTTA JUG

I have fondly worked with one very special, beautifully proportioned, Italian wine-jug for over twenty years and I believed that I knew all its characteristics. Understandably, I developed a phobia about breaking it. The jinx would be removed, or so I thought, by finding a standby replacement. Good hunting grounds are flea-markets and charity shops, or the occasional jumble sale, and after a long search, I found, to my relief, one identical in shape and size with only the string around the handle missing. And yet something was wrong – it just didn't feel right to me – and only through painting the facsimile did I realize the true value of the original: disgusting though it seems, the pastel grime, heavily engrained through time on to the surface

ABOVE **'Derry's Tulips'** 26x38in (66x96.5cm). Oil pastel. (*Collection of Mr G. Sarson*)
A bouquet of flowers.

and twisted handle string is what gave my terra-cotta jug its unique texture and special quirks. In some lights, its earthenware tones changed from red-brown to ochre, but as I usually put pots into a painting only after I have finished with the flowers, I am never quite sure which tint of brown will be selected until I have worked out the tones which will give me the greatest contrast. It is important to remember that you could be working in two separate colour fields at this point. For example, in my painting 'Midnight Tulips' (see page 84) the giant, scarlet petal draped over the jug has a primary colour which belongs to the inner spectrum circle of the colour wheel, whilst the jug's burnt-sienna brown belongs to the family of tertiary hues found at the outer edges of the colour wheel.

WHITE MILK JUG

It is useful to own at least one fairly large white container that will go with practically any type of flower. Although a bit on the plain side, the one I use most in my paintings has a rather charming handle that adds interest to the part of a composition that sometimes needs livening up, because most of the attention has been focused on the middle and upper part of the design.

In my oil pastel painting, 'Derry's Tulips', a massive pale green leaf cuts through the middle of the handle by draping over the edge of the milk jug, while on the other side two undulating leaves break up the rather tonal blandness of white.

ALHAMBRA JUG

My daughter has recently introduced a third flower jug into my repertoire, which, amazingly, she managed to carry all the way home from Granada in Spain without damage, though by the look of it one would not think so, as its

entire surface is decorated with minute, cracked, convoluting threads similar in appearance to a broken spider-web. What I find most engaging about the pitcher is the simple, hand-made look of the handle and flower motifs, which are painted in an attractive deep lilac over these circular lines.

It is an artist's prerogative whether or not to include all information about a particular subject in their composition. On my first attempt, I left out all the patterns and just drew the outline of the jug. However, in my painting 'Guernsey Orchids' I have rendered a fairly accurate description of colour and shape. It would have been too time-consuming to portray all surface texture and I knew intuitively that the end result would look fussy. So I deliberately simplified the decoration by leaving out some of the detail and enlarging the web pattern. Perhaps, at a future date, after I have familiarized myself more with the jug, I will put in all its features. I suspect this will involve working, rather laboriously, with a combination of pastel and pastel pencil and I will have to wait until I am in the right mood!

For many years I have drawn natural forms without any conscious desire to transform them symbolically, thereby endowing them with psychological importance. I have developed such a personal attachment to my various pots and jugs and other household items, that the special relationship I have with them is gradually creeping into my floral compositions and I am aware of the fact that my flower and plant images may be substitutes for human experience. I hardly ever portray people in my large pastel art work, for

RIGHT **'Guernsey Orchids'** 32x24in (81x61cm). Soft pastel.
The elegance and structured simplicity of orchids, sent to me as a gift from the Channel Isles after I had done a pastel workshop with the islanders, were the inspiration behind my favourite vibrant painting.

BELOW **'Orchids in Alhambra Jug'** 22x30in (56x76cm). Soft pastel.
In contrast to 'Guernsey Orchids' the background colour and horizontal shape of this painting dramatically alters the impact of the image.

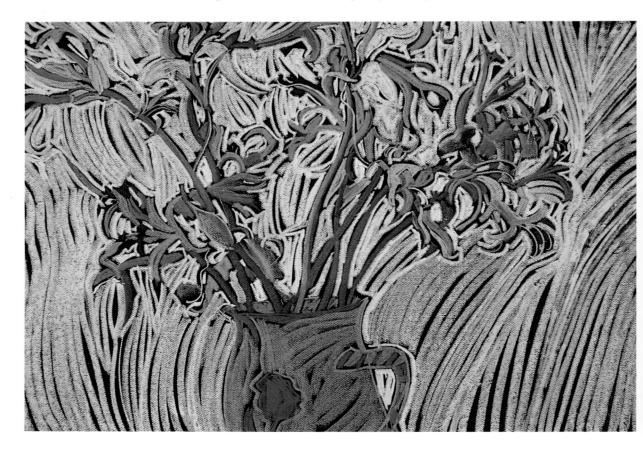

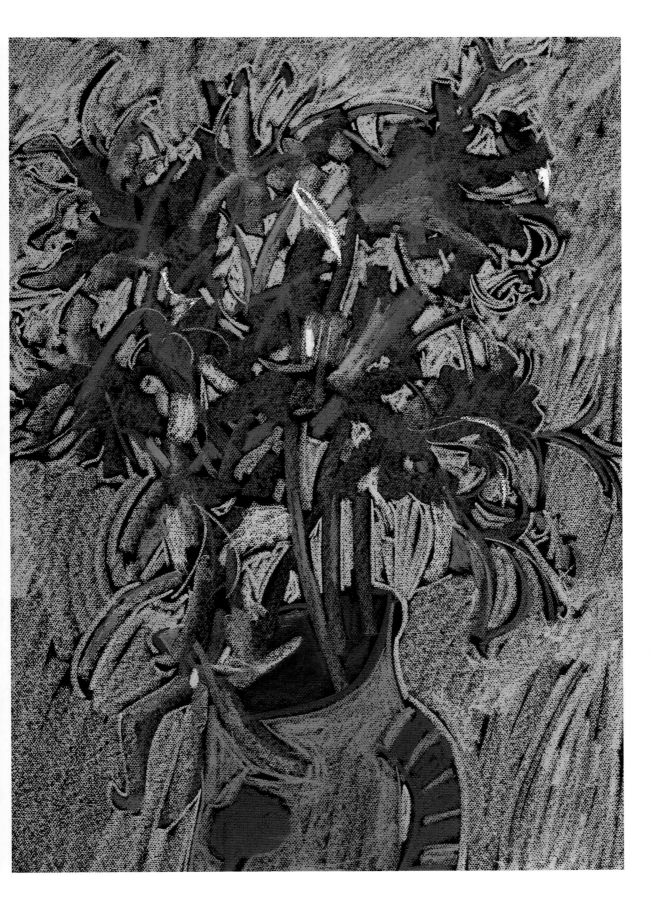

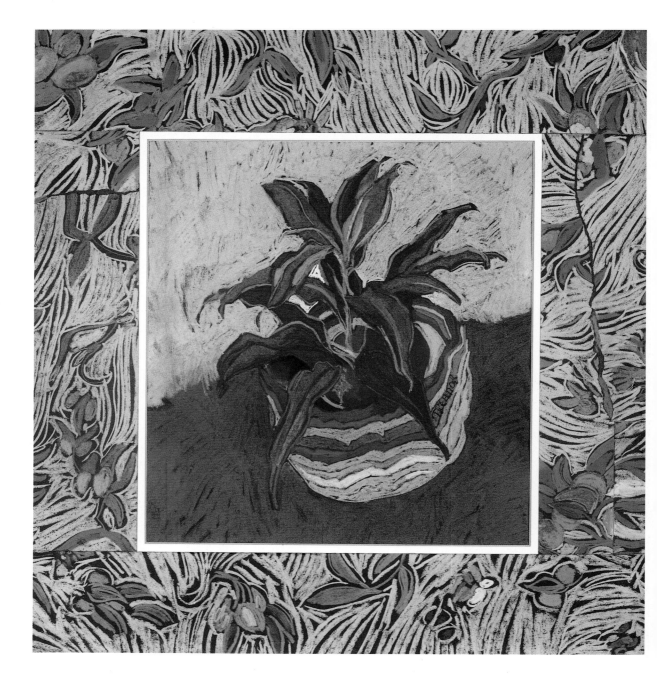

the human image is the most powerful of all and consequently its very familiarity can divert attention away from the surrounding imagery, because of its highly subjective and conditional response.

Nevertheless, in my painting 'Celtic Woman', I feel that to some extent I have overcome this dilemma. 'Dracaena and Pomegranate' (above) and 'Amaryllis' (page 6) are two other paintings which appear to contain, for me at least, a human element; although there is no

ABOVE **'Dracaena and Pomegranate'** with border 27½x26in (70x66cm). Soft pastel.
A plant portrait with a human element.

RIGHT **'Celtic Woman'** 40x27½in (101.5x70cm). Oil pastel and chalk collage on grey sugar paper.
Enlarged flower seeds form a backdrop which camouflages the figure of a woman.

actual figure, there is a strong feeling of isolation and mystery due in part to the ethnic bowls in which the plants were housed.

ABOVE Tertiary colour chart of earth tones suitable for colouring terracotta pots.

ABOVE A three flowerpot group.

ABOVE Flowerpots on a two-toned, diagonal background.

ABOVE Flowerpot group.

RIGHT A Flower Pot.

BASKETS

Tired old shopping baskets made of straw or wicker which would normally be thrown away, as the handle has snapped or the bottom has collapsed, make terrific cover-up screens for ugly plastic pots. If you are lucky enough to find an ethnic basket with interwoven coloured twine, as I did once in a builder's skip, it is very easy to mend the base, if it has fallen away, by putting a plate inside. This should keep any pot or growing plant on an even keel and will also stop the penetration of water.

Mixed bunches of dried flowers also look superb arranged in huge wicker baskets, and if the handle is still intact it provides a more natural-looking support for the stems. Just remember to take a little extra care with delicate plants, such as Chinese lanterns or honesty which have an irritating habit of latching on to any loose strand. Giant clay pots are prohibitively expensive, and if not frostproof, can easily be damaged.

It is possible to give discarded laundry bins made of rope a second lease of life by converting them into pots. Their matching lids can also

serve as a base if necessary. Swiss-cheese plants, yuccas and kentia palms can all live happily with each other inside these larger baskets.

GARDEN PLANTS IN POTS

The first thing to notice when looking at an object you wish to draw is its form. Is it round, square, triangular or a mixture of all three? A few small, very simple, quick sketches at this point will make it easier for you to make up your mind, and once the geometric shape has been established the next stage will be to work out the proportions. If you are drawing plants in garden pots it is wise to think of the plant and the pot as two completely separate forms so that you can work on paper that is large enough to accommodate both. Occasionally, I haven't allowed enough room for the container because

ABOVE RIGHT '**Study of Geranium in Flowerpot**' 17x14in (43x35.5cm). Pastel and watercolour paper.

RIGHT '**Fuchsia in Large Pot**' 15x13in (38x33cm). *An unusual combination of a giant pot with a tender plant.*

BELOW '**Busy Lizzie in Small Pot**' 13½x13⅓in (34x34cm). Soft pastel.

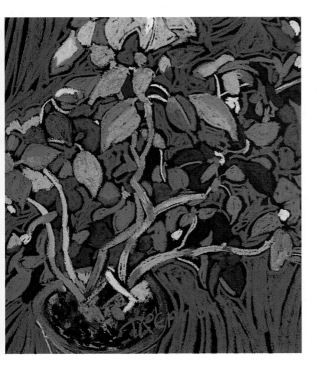

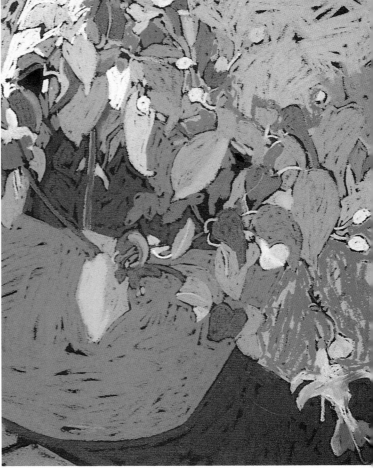

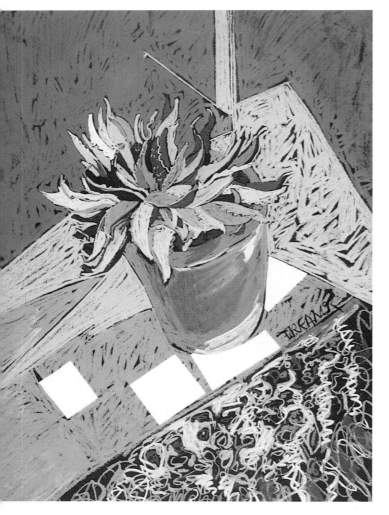

the stems of a plant have been taller than I real-
ized and because I normally work down from
the top of my paper. However, it is better, visu-
ally, to run out of space for the pot rather than
the other way around, otherwise the drawing
might look a little odd.

Drawing a group of empty flowerpots from
various positions will help improve your sense of
rhythm and perspective. Clean plastic pots are
more suitable to study at the beginning because
of their simplified regular form and interesting
reflections. When you feel confident enough to
tackle colour, I suggest that you use clay terra-
cotta pots instead, for they have much more
charm and character, especially the older ones
that may be a little chipped.

Conté crayon is ideal for colour drawing, for
it was the traditional medium used for centuries
in art studios. Sanguine and bistre are made of
identical compositions to pastel pencil leads and
these particular tints will match the colour of
terracotta pots, besides giving you controlled,
attractive drawings. Shading or colouring in
large areas is also possible with these crayons if
they are used flat on their side, or sharpened
with sandpaper to a chisel tip: try to follow the
pot's circular contours with any directional lines,
as this will make your pot appear more rounded.
Delicate touches of soft powder pastel, for
instance yellow ochre, can be applied on top of

ABOVE **'Bathroom Cacti'** 38x25in
(96.5x63.5cm). Oil pastel.
*A bold personal interpretation that
allows for multiple view-points and the
distortion of space.*

RIGHT **'Iris Root'** 17x24in
(43x61cm). Soft pastel.
*Tertiary colours can be fully explored
in great depth by studying the subtle
greys and brown tones in garden peb-
bles and soil.*

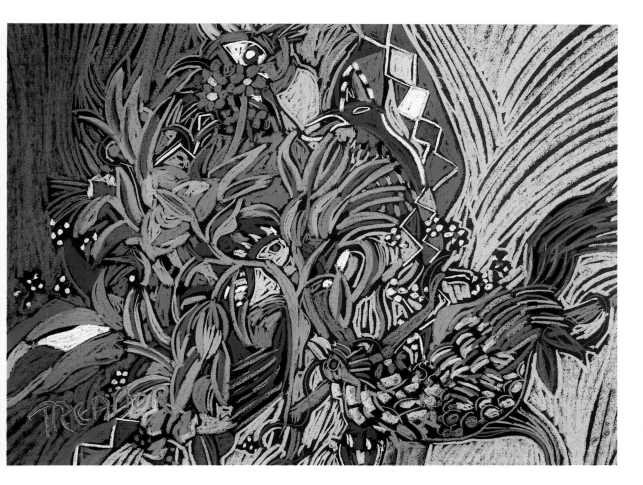

Conté crayon afterwards, to highlight the rim of the pot.

I now use multiple viewpoint perspective in my drawing where emphasis is placed on the change of plane rather than recession. I am not interested in creating an illusion of space by studying receding line and as a result my shapes can have contours or edges that sometimes ambiguously veer off in different directions, for example in my paintings 'Aspidistra' and *'Lilium Regale'*. I really enjoyed weaving the orange flowerpot rims in and out of the plant's foliage. A leaf crossing the path of the rim of the pot makes my design more exciting, because it breaks up a strong horizontal area in the forefront of my picture. In its absence, I would conveniently borrow one from another section – artistic licence!

Tertiary colour can be exploited in full by picking up the subtle greys and brown tones in natural soils. I adore playing off one colour texture against another but the artificial compost in some of my pots can become tedious to look at after a while. Scattering a few leaves, one or two pebbles, or a brightly coloured petal on top usually brightens things up. If you are able to arrange pots at ground level and then perch on a small ladder above your composition, you will have a bird's eye view which will make it easier to see the earth inside your pots and this unfamiliar position will also stimulate the imagination.

PATTERN AND DECORATION

There appears to be an unwritten rule, among the Western art establishment, that undermines the integrity of decorative or pattern painting by treating it with less value or respect, in intellectual

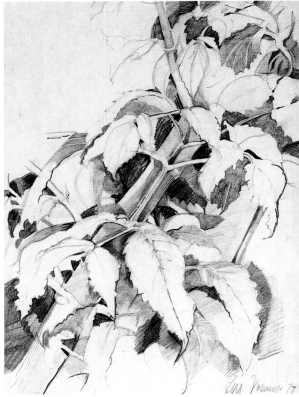

ABOVE '**Sunflower Head with Terracotta Pot**'
16x13in (40.5x33cm).
A variety of graphite pencils were used in this detailed drawing of a sunflower, ranging from HB to 6B. The centre of the seed head was deliberately smudged and highlighted with a kneaded putty eraser.

TOP RIGHT '**Flower Stem, Kew Gardens**'
19½x13½in (49.5x34cm).
Many hours were spent carefully drawing the stem and leaves of this plant in Decimus Burton's botanical greenhouse at Kew Gardens, London. A range of graphite pencils from HB to 6B were used to portray variations in tone.

terms, than its minimalist counterpart. The roots of this phenomenon lie, perhaps, in the historical division between men and women and the traditional cultures of East and West. Creating a work of art without pattern or decoration would be inconceivable to the Arab world.

In nature, objects devoid of pattern would cease to function properly, because pattern is an integral part of their formation. Natural patterns grow and develop as the shape itself matures and they become an essential part of the structure. Since form and pattern are created simultaneously, the relationship that exists between the two is one of harmony, and appreciating this principle is the key to good design.

Unfortunately the efficiency, or usefulness, that links pattern to shape in the world of nature, need not apply to man-made objects, especially those deliberately created as works of art. If pattern is added as an afterthought, then it is unrelated to its material and becomes superfluous decoration.

PATTERN IN PLANTS

I have always been drawn to the world of plants and flowers because I feel comfortable with them around me, and as an inspiration for design and colour they are unbeatable. At my first, inner city, art college, I had hoped that it would be possible to continue botanical painting with the watercolour skills I had acquired in convent school, but emphasis was directed towards a more industrialized approach, using urbanized waste as source material. The only real chance that I got to include flowers in my portfolio was in my thesis on William Morris's floral patterned wallpaper.

A further decade elapsed before I returned to flower illustration. This time, inspired by Decimus Burton's greenhouse and the gardens at Kew, I produced black-lead pencil drawings of

trees, flora and buildings; one of these won Special prize at The Law Society Art Group later in the year. This gave me back the confidence I had lost as an art student by enabling me to make further studies of flowers without apology.

Through the careful study of a plant's structure, I was able to appreciate that no leaf or flower is identical even if from a distance it may appear so as minute patterns manifest themselves as a single textured unit. The continuous repetition of a single unit enhances rhythm and, in the living world, provides strength where the geometric shapes link in with one another, each dependent on the other in order to function. The strongest geometric shape found in the natural world is a triangle. If you look at the veins of a leaf or up through the branches of a tree, it is possible to see these triangular patterns.

When sketching or painting complicated rows of bedding plants and foliage in a garden or municipal park it helps to make sense of their multiple forms and tones by simplifying them. It isn't necessary to draw or paint every detail to capture a likeness; too much attention to detail can destroy spontaneity, beauty and character.

By selecting one shape from the overall image and an appropriate colour from a very limited palette, a complex mass can be reduced to a simple grouping. By this method any pattern can be made into a texture. Greater attention to detail should be applied at a later stage.

BACKGROUNDS

If a flower study is full of interesting shapes which are harmoniously balanced throughout the entire composition, then there should not be much of a problem with the background. In my own work I often place complex shapes behind my flowers to add interest, excitement and intrigue. At first glance it is not always easy to recognize those images because they have become entangled with the foreground. At other times I let one colour, usually a blue, fill the background space. If more than one colour is added, then I run the risk of drawing attention away from the main flower theme.

BELOW **'Sara Tulips'** 26x38in (66x96.5cm). Soft pastel. *I like to fill an empty background space with a strong vivid blue or green which will enhance my subject matter.*

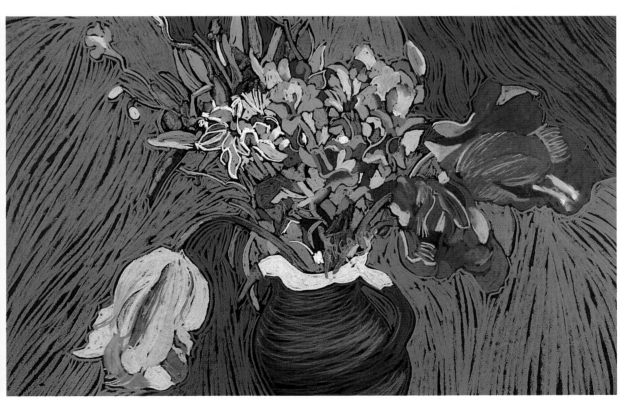

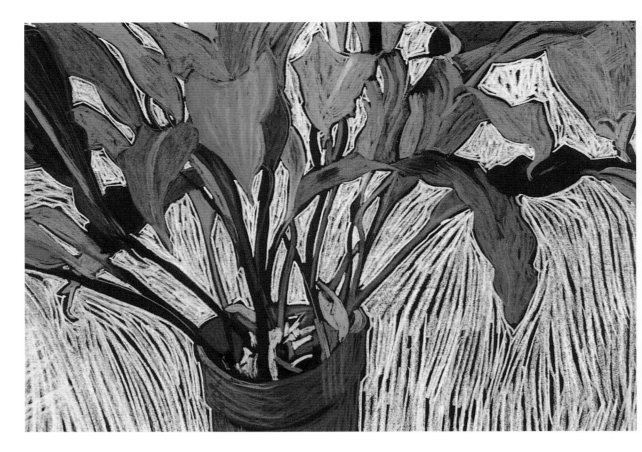

ABOVE '**Aspidistra II**' 25x38in (63.5x96.5cm).
Oil pastel.
The shapes in between other shapes are of equal value when drawing in a positive and negative way.

There are two principal methods of looking at space in a composition: you can think in terms of foreground – the shapes that are nearest to you; and the middle distance and background are the shapes that are farthest away. Most traditional drawings and paintings since the Renaissance have represented all such distances by making the line marks or colour tones sharper in the foreground and muted, even blurred, in the background.

However, a more challenging approach is to think in terms of drawing and painting objectively where there is no distinction between the foreground or the background, only the analysis of positive and negative shapes. Admittedly it will take much longer to work by this method but intellectually it is far more satisfying.

Most of us respond to an object in a personal, subjective way. If that image is recognizable,

chances are that once identification has taken place we will no longer, because of our preconditioned response, be able to see the image afresh. Furthermore by drawing and analyzing things objectively in unfamiliar situations or positions our powers of observation will develop.

POSITIVE AND NEGATIVE SHAPES

When drawing the outline of an object it is easy to become so totally engrossed in its form that you fail to notice the surrounding negative, or empty, areas. The consideration of both kinds of positive and negative shapes is essential for good draughtsmanship and the assessment of the relationship between these shapes. Both the positive drawn object and the negative gap or space between the object should be viewed equally. Keeping the two areas plain and flat, devoid of superfluous detail, such as shadow, will help to heighten a sense of colour, pattern and rhythm and should make it easier to understand their form. Colour relationships will also have to be respected so that the delicate balance between

objects and their tonal hues is maintained. The two paintings 'Rubber Plant' (page 90) and 'Aspidistra II' (opposite) are examples of paintings in which a careful analysis of positive and negative shapes has been made.

PUTTING IN A BACKGROUND

Some flowers are so captivating in themselves that it is better to paint them on their own with only a jug or vase to hold them in place, and the backgrounds can then simply be left as plain paper. However, a disadvantage of leaving the surrounding area empty, especially if it is white, is the risk of making a dirty mark on the remaining uncoloured paper should any soft powder pigment dust work loose. Even after heavy fixing this can happen and it is so irritating once the painting has been framed under glass. It was precisely for this reason that I developed a method of adding highly-coloured backgrounds to my work, often with quite complicated designs, so that if accidents occurred they would not be so immediately noticeable.

This has led towards the creation of some very exciting designs using patterned fabrics and curios. I discovered that it was not necessary to arrange them all together in one sitting because the random placing of them was far more intriguing. By adding objects to my still-life paintings as each silhouette or contour emerged, I felt controlled more by my inner feelings rather in the manner of the Rorschach ink blot test where, depending on imaginative mood, the more one fantasizes, the more daring the symbols become.

OVER PAGE **'Reflections of India'** 23x33½in (58.5x85cm). Soft pastel. (*Collection of Mrs J. Jordan*)
The highly patterned shawl and jug in this painting are of sentimental value to the owner, for they once belonged to her mother, who was a great traveller. I added my own personal touch by including some strawflowers and an antique Chinese bowl which I had inherited from my own mother.

BELOW **'Zinnias in the Park'** 24x32in (61x81cm). Soft pastel.
In spite of a windy day these flowers were robust enough to withstand any breeze that blew through them and consequently made the perfect flower model.

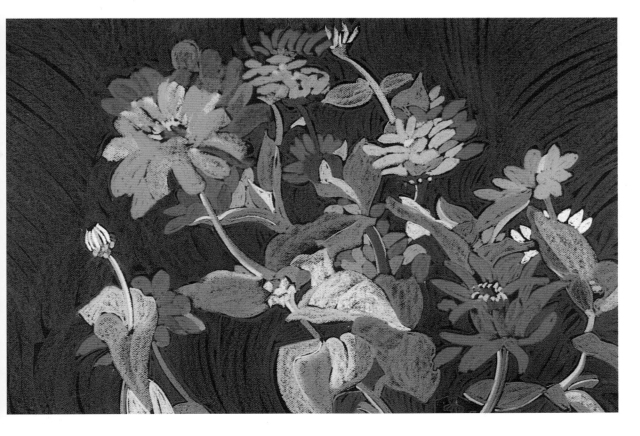

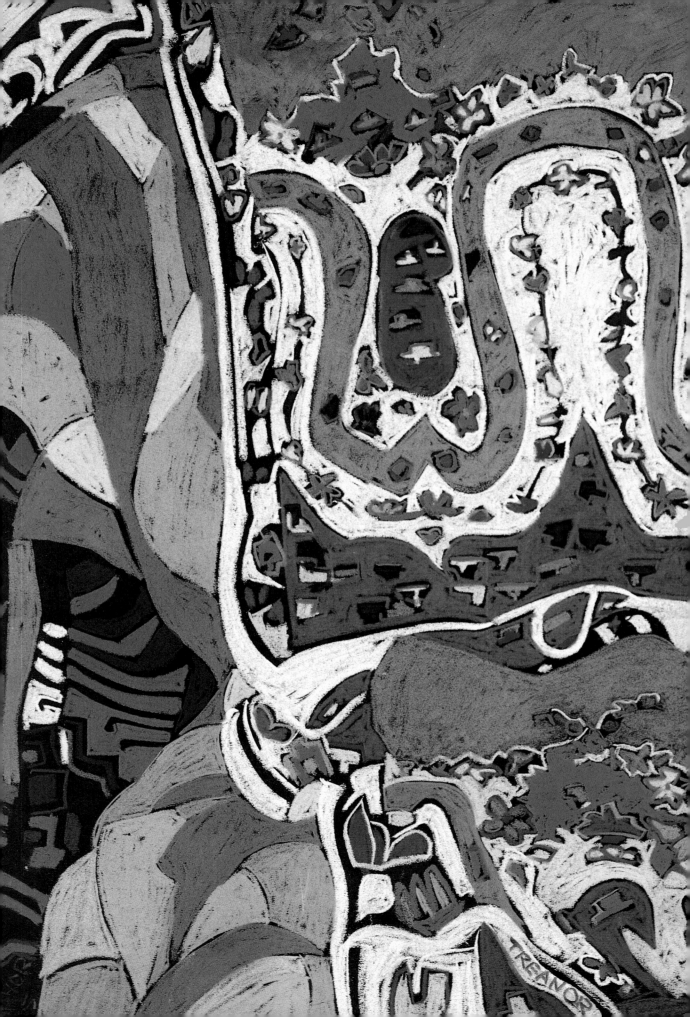

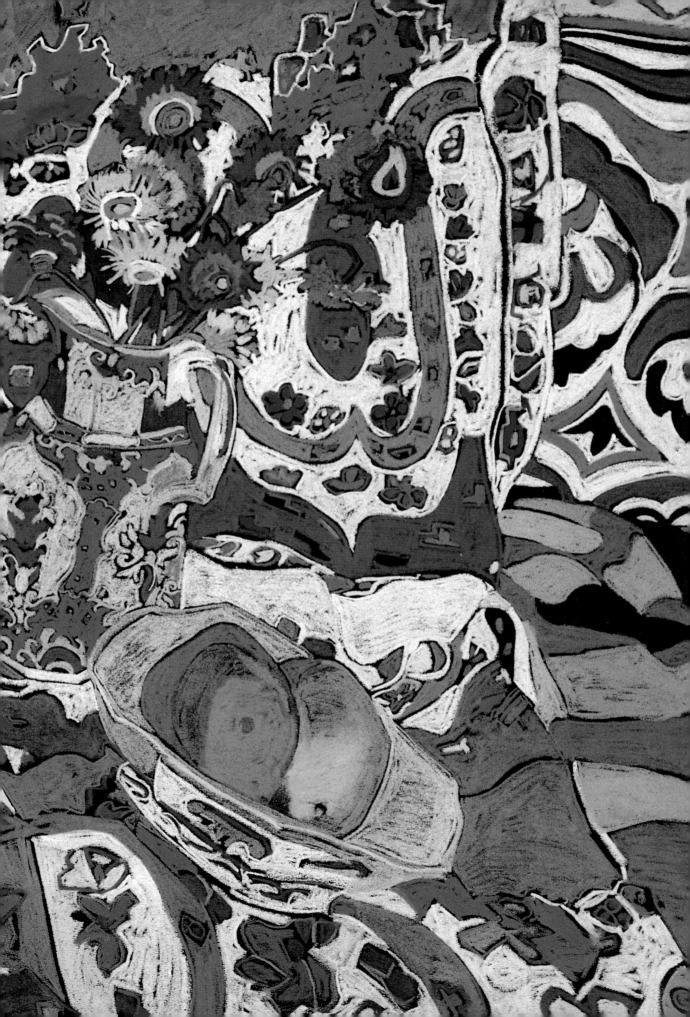

Chapter 8
PROTECTION AND STORAGE

. .

PROTECTING YOUR PASTEL PAINTINGS

The fragile nature of the pastel medium makes it necessary to protect it as soon as it is applied to a surface, and whilst fixative goes a long way in preventing the pigment from falling off, it should be regarded only as a temporary measure until more permanent protection is afforded. Some pastellists prefer to dry mount or glue their finished painting on to a thicker board as a further safeguard against damage to thin paper; other artists even seal the top of the actual painting itself with strong varnish or by dry mounting. I would advise against this procedure as it

may cause problems in the long term. However, provided only acid-free materials that will not discolour or eat into the painting are used, then normal fixing is the best practical way of protecting them. The painting can then be covered with tissue paper or put into a clear polythene bag and stored in a flat position away from heat or damp until it is framed under glass or perspex.

LEFT **'Garden Roses'** 30x22in (76x56cm). Soft pastel. *With very soft blended pastel I have tried to emulate the gossamer texture of a climbing rose.*

RIGHT **'Lizzie with Daffodils, Covent Garden'** 8x6in (20.5x15cm). Neo-pastel and felt tip on sketching paper, glued on to black mount board.

BELOW LEFT **'Melting Pot with Fleur-de-Lys'** 10x11½in (25.5x29cm). Neo-pastel on white paper, mounted on a cut-out oval board.

BELOW MIDDLE **'Princess with Tulip'** 12x12in (30.5x30.5cm). Neo-pastel on white paper, glued on to coloured board.

BELOW RIGHT **'Menton, Côte d'Azur'** 4x5 (10x12.5cm). Oil pastel on white sketching pad, mounted on to museum card.

LEFT **'Paeonies'** with border 29½x28in (75x71cm).
Soft pastel collage.
*I have developed a technique of enlarging the size of my
pastel paintings through applying pastel to the surrounding
mount, but I always take care to make any such addition
an important feature of the overall design and not a mere
decorative extension. This way of painting is also very use-
ful in disguising the soiled parts of a damaged mount.*

RIGHT **'Camellia on Tweed'** 33x23in (84x58.5cm).
Soft pastel.
*A tartan car rug disguises an ugly wood fence in a garden
where the camellia was growing.*

MOUNTS

Traditionally a pastel drawing is secured to a
bevelled (slanted edge) card mount with an
adhesive strip (passe-partout) or acid-free linen
tape (but never use Sellotape), so that the glass of
the frame does not actually touch the picture, so
preventing frosting, or rubbing off. With larger
paintings, where a mount would be impractical,
small wooden frame inserts can be placed on the
inside of the frame to prevent contact. Mounts
can be cut to any reasonable size with a Stanley
knife and a straight-edged steel rule or you can
invest in a more professional mount-cutting kit.
Ready-made mounts in small standard sizes are
also available in some art and stationery shops.

However, it is also possible to buy mounts, at
a greatly reduced price, which are slightly soiled
or have been cut out of true, from the off-cut
bins in framing shops. Most errors are made in
the measuring of the mounts, so it is easy to pick
up several different coloured ones in this way,
and by overlapping them, you can usually make a
mount big enough to fit around a picture. The
width and colour of a mount can dramatically
alter the visual effect of a picture, and former
mistakes in a design, such as a focal point unwit-
tingly created in the middle of the paper, can be
repositioned by moving the inside window of the
mount around the art work until it looks right.

I have developed a technique of enlarging the
size of my pastel paintings through applying pas-
tel to the damaged parts of mounts, but I have
always taken great care to make any such addi-
tion an important feature of the overall design
and not a mere decorative extension.

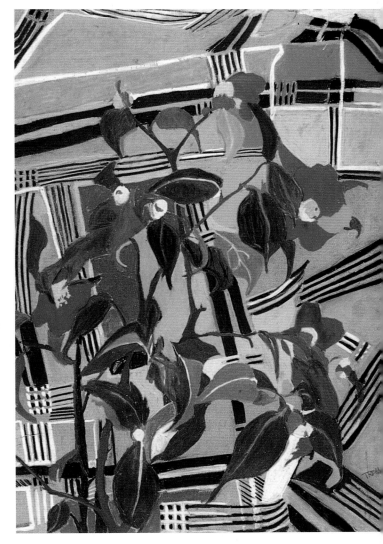

FRAMES

The appearance of a picture can be transformed
by its surrounding frame and the choice of mat-
erials is wide, if somewhat expensive, especially
when selecting wooden moulds. Many artists,
however, are skilled at carpentry and find the
cutting and the joining of battens easy. It is a
task that I prefer to leave to the professionals,
even though there are some excellent ready-
made assembly kits available from mail-order
catalogues and leisure painting magazines.
However, my costs have been minimized
through buying good quality old frames with a
bit of character from antique markets or auc-
tions, so that all I have to do is clean and polish
them up and replace any broken glass or missing

frame backing with hardboard. I like to cover the reverse side of my pastel paper with a sheet of acid-free tissue paper which will act as a barrier against a non acid-free backing board. The outer edges of the hardboard are then joined to the sides of my frame with nails or screws, and finally sealed with masking tape or gum strip at the joins to prevent dust or mite entry.

STORAGE

Pastel paintings, either with or without mounts, should be carefully stored separately, away from other sheets of used or unused paper, in order to keep them clean, dry and safe. They can then be kept in a large-sized plan chest or on dust-free

shelves until you are ready to frame them for exhibition in a gallery, or they could be hung on your own walls to give you and your friends many years of pleasure.

Finding a place big enough to store all your pastels is not so easily resolved, because you will be constantly adding to your collection as your work develops. Small free-standing book shelves

secured firmly to a wall are a convenient storage place for new, unused cartons and boxes of pastels. However, once they are in use it is better to store them in open boxes for easy access. The wooden cutlery trays and small reed bowls that I have picked up from antique and bric-à-brac markets over the years are ideal for storing and dividing the different colours and types of pastel. Off-cuts of see-through rigid plastic keep the dust off and allow me to choose chalks quickly without too much disturbance. If art materials are packed away too neatly they are unlikely to be used, so always keep them to hand.

I no longer have a spare bed ready for house guests, for it is now home to all my pastel storage trays. The rainbow displays of colour are a lovely sight. To stop residual pastel dust from penetrating into the mattress, an old, worn but attractive, tightly-woven Indian rug, hardened through washing, is thrown over the top and is easily cleaned with a vacuum or foam carpet-shampoo, or when it gets really grubby is easily washed in the bath.

Additional storage and workspace for art materials can be gained by converting a sealed wood door such as pine into a table-top which is supported either by trellis or bricks. Some of the recess panels can be filled in with plywood and the remaining ones can act as a buffer for pastels and pencils, preventing them from rolling off on to the floor.

..

WORKING CONDITIONS
AND EQUIPMENT

..

If you are fortunate enough to have your own studio, then finding room to arrange still-life compositions will not present too much of a problem. Most artists either have to share with other people or set aside a small space in their home and this can make compositional painting very difficult because it is essential to have access at all times to your work when the urge to paint comes. I have never felt very comfortable working with other artists around me, for I find the

LEFT **'Pansies and Chrysanthemums'**
25x35in (63.5x89cm). Soft pastel.
A composition rich in colour.

competitive element disconcerting, yet at times, especially with figure drawing, it would be too expensive and somewhat inhibiting to hire a model on one's own, so painting in a group on these occasions is more practical and fun.

Most of my art work is done in the comfort of my home, where I can safely leave a painting at the end of the day undisturbed until it is finished. I have made it a house rule, no matter what, to tidy up after each session. This is very important if you are working in pastel, as the pigment has a habit of clinging unnoticed to the soles of your shoes (or in my case a pair of old slippers!). Keeping a vacuum cleaner and a bottle of white spirit nearby will remove most pastel residue but as a safety precaution with so much paper around, all smoking is banned and highly inflammable solvents are removed at night to an outdoor garden shed.

In the winter months the light in my main studio is very poor and its north facing flank wall

catches a chill wind that blows up from the River Thames, making the room very cold and uninviting. As a consequence, all the rooms in the rest of the house have at some time or another been converted into makeshift studios. I have invested in some mobile arc-lamps that can focus the light directly on to my work and my most prized possession is an elephant-size, 4x3ft (1.2x0.9m) antique plan chest that holds my pastel paper flat, protecting it from creases and moisture. Cheaper papers are stored in a rolled up position in large wicker shopping baskets, which also double as still-life props when needed.

A few years ago I bought a large second-hand radial studio easel which could be adjusted to numerous height positions, but this has turned out to be a false economy as a pastellist needs an easel with a forward and backward tilt at the centre joint, which will allow for both flat and upright work. As an alternative, I managed to find a child's nursery easel big enough to accommodate large pieces of paper and sturdy enough to hold a large drawing board at a slight angle, thereby stopping chalk dust from falling down. If I want to arrange fabrics as a backdrop to a composition, I drape them across my other smaller portable easels, tall chairs or drawing boards secured with masking tape: it isn't a good idea to use walls, even with adhesive poster tacks, as the weight of the fabrics might cause damage.

Extra-large wooden drawing boards are wonderful to work on but they are cumbersome and very costly to buy. I have witnessed many accidents with them when they have toppled off a radial easel, or have brought the entire easel down with their sheer weight because they were improperly balanced or the locking wing-nuts had worked loose on the easel. As an alternative support, strawboard (compressed sheets of cardboard) is lightweight, cheap and readily available from DIY stores. If bound on all four edges, in order to stop fraying, and covered with thick wrapping paper, it should give you many years' use. When measuring up a support for your paper remember to allow enough room for the pastel to bleed off the edge and allow space for dog-clips and masking tape.

LEFT **'Pink Flowers in Pot'** 18x14in (46x35.5cm). Soft pastel.

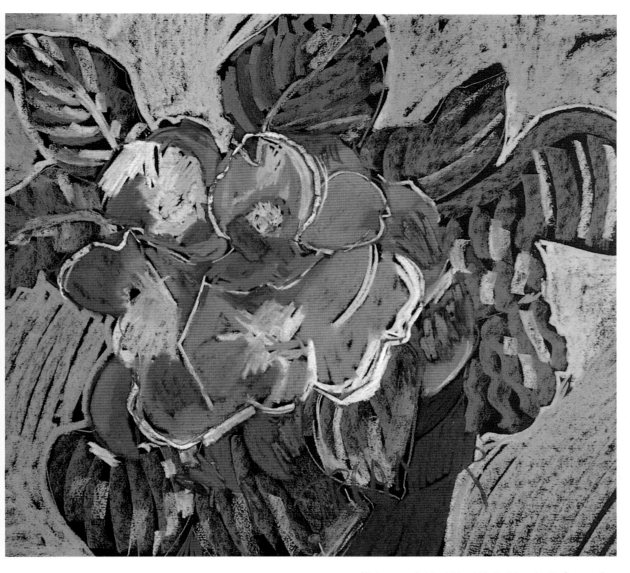

ENDNOTE

It really does not matter what subject you choose to draw or paint or which material you choose to work with; some subjects are more stimulating, some media more responsive than others; it is finding the harmony that exists between the two that is the secret of good, creative work. For centuries artists, craftswomen and craftsmen have recognized that the flower is a powerful source of inspiration, and they have used its motif in countless ways and in many media.

I, personally, have learned more about design and colour theory from painting flowers and plants directly from nature with pastel than I

ABOVE **'Primrose'** 25x35in (63.5x89cm). Soft pastel. *I am not particularly fond of this small plant as it looks too wizened and out of place in a domestic garden, except under the shade of a large tree. To counteract this I deliberately exaggerated the size and softened its texture.*

OVER PAGE **'Chrysanthemum Cluster'** 31x38in (78.5x96.5cm). Oil pastel.

ever did from a text book. Their ever-changing foliage increases my awareness of geometric shape and tertiary colour; their structure teaches me more about basic principles of design; and flowers challenge my conception of primary colour with their unexpected juxtapositions of hues. Best of all there is the added bonus of working alongside a thing of beauty.

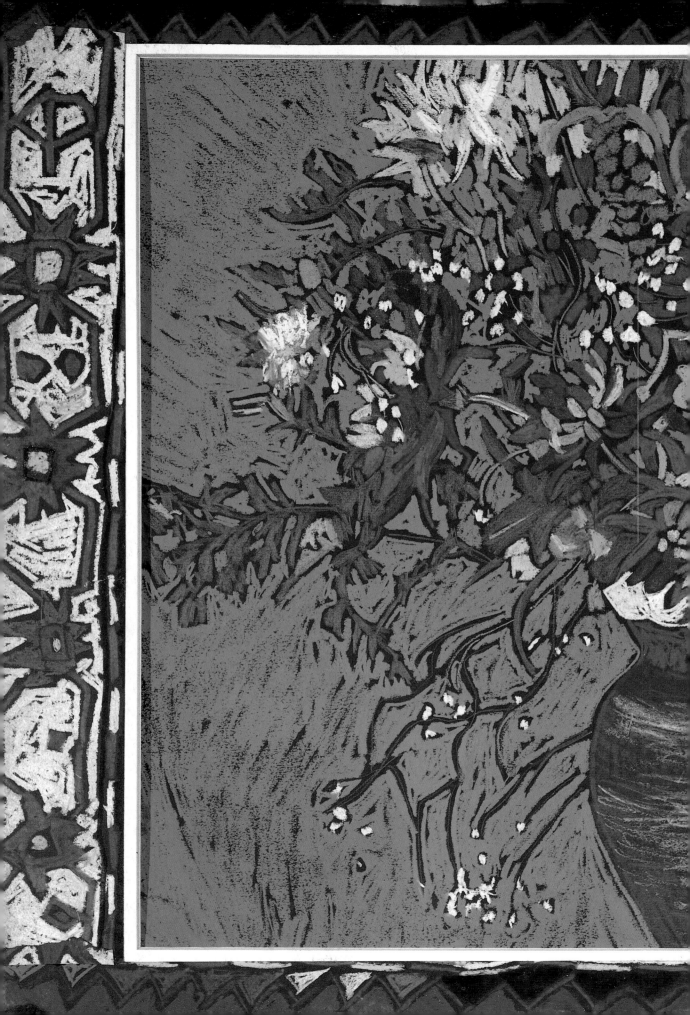